William Morris

Masterpieces of Art

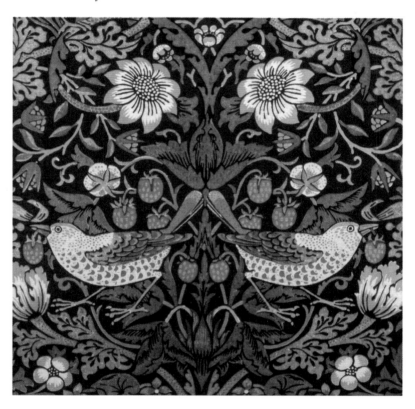

Publisher and Creative Director: Nick Wells
Senior Project Editor: Catherine Taylor
Picture Research: Sara Robson and Catherine Taylor
Art Director: Mike Spender
Copy Editor: Anna Groves

FLAME TREE PUBLISHING
6 Melbray Mews
Fulham, London SW6 3NS
United Kingdom

www.flametreepublishing.com

First published 2014

22 24 26 25 23
3 5 7 9 10 8 6 4

Front cover: 'Seaweed', block-printed wallpaper, 1890s, probably by John Henry Dearle (1859–1932)
courtesy of The Stapleton Collection/Bridgeman Images.

Back cover: 'Pink and Rose', block-printed wallpaper, 1890,
courtesy of Private Collection/Bridgeman Images.

Image Credits: Courtesy of Bridgeman Images and the following: 10 Bradford Art Galleries and Museums, West Yorkshire, UK; 23, 108 Kelmscott Manor, Oxfordshire, UK; 30, 31, 32, 35, 37, 39, 40, 42, 45, 46, 47, 50, 52, 59, 61, 65, 66, 68, 70, 79, 80, 83, 84, 86, 87, 88, 91, 92, 94, 98, 100, 114 Private Collection; 33, 34, 36, 38, 41, 43, 48, 51, 53, 55, 56, 58, 60, 62, 64, 74, 106 Private Collection/The Stapleton Collection; 44 Deutsches Tapetenmuseum, Kassel, Germany/ Museumslandschaft Hessen Kassel Ute Brunzel; 54, 90 Calmann & King, London, UK; 75, 102 Victoria & Albert Museum, London, UK; 76, 110 Art Gallery of South Australia, Adelaide, Australia / South Australian Government Grant; 82, 112, 113 Whitworth Art Gallery, The University of Manchester, UK93 William Morris Gallery, Walthamstow, UK; 103 Private Collection/ John Bethell; 104 Private Collection/The Fine Art Society & Francesca Galloway; 111 Private Collection/The Fine Art Society, London, UK; 116 Trustees of the Watts Gallery, Compton, Surrey, UK; 118 Private Collection / Photo © The Fine Art Society, London, UK; 121 Private Collection/The Maas Gallery, London, UK; 122 Birmingham Museums and Art Gallery; 124 Hermitage, St Petersburg, Russia. Courtesy of **Alamy** and © the following: 11 David Ball; 15 Arcaid Images; 69, 120 V&A Images; 99, 107, 115, 119 The National Trust Photolibrary. Courtesy of **Flame Tree Publishing Ltd:** 14. Courtesy of the **University of South Carolina:** 16, 25. © **Victoria and Albert Museum, London:** 78.

Dropped caps and decorations are based on William Morris's original typography for the Kelmscott Press

ISBN: 978-1-80417-336-7

Printed in China I Created, Developed & Produced in the United Kingdom

William Morris

Masterpieces of Art

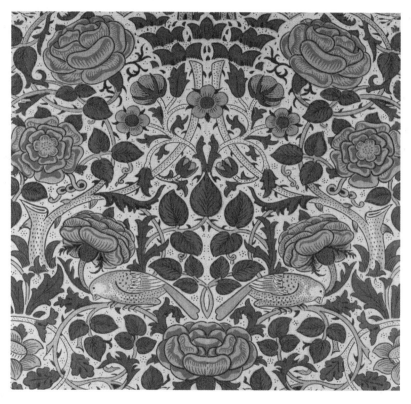

Michael Robinson

FLAME TREE
PUBLISHING

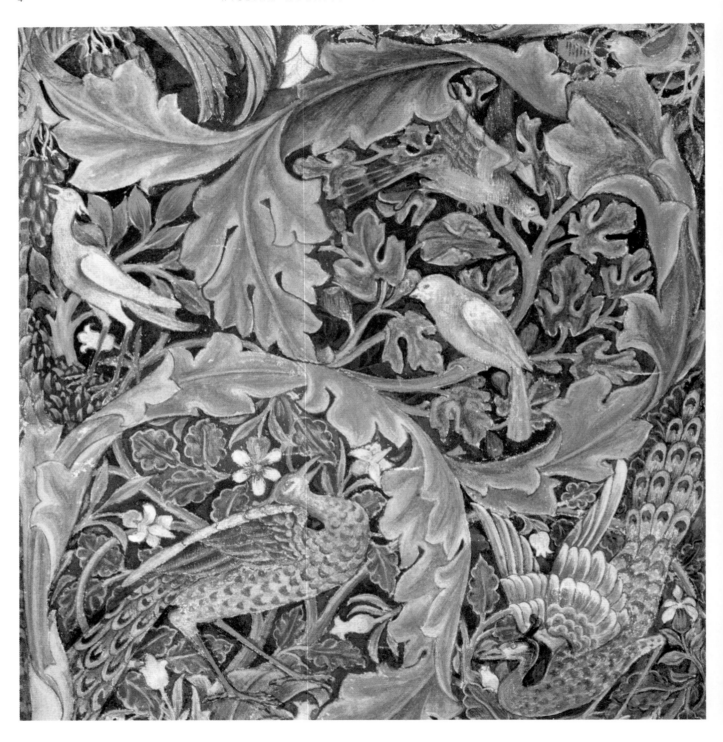

Contents

William Morris: Arts & Crafts Pioneer

 illiam Morris (1834–96) was an artist, designer, writer and political activist at a critical time in Britain. In 1851, when Morris was just seventeen years old, the Great Exhibition opened in London's Hyde Park, the first of the so-called 'World Fairs' showcasing the latest inventions and designs from around the globe. Here, Britain, the leader of the Industrial Revolution, was most definitely at the forefront. However, there were some, including Morris, who were critical of the poor design and manufacture of these objects.

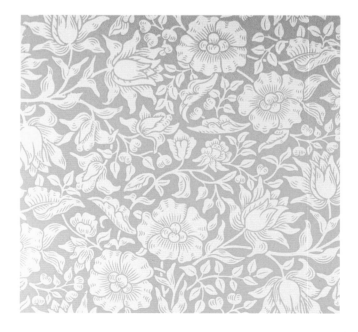

Morris and a few like-minded individuals initiated a movement to return to the craft-based skills lost in the Industrial Revolution, which he blamed for not only lower standards in design and manufacture, but also the diminished morale of the working classes. Morris proposed a return to the traditional methods of a pre-revolutionary era, when people took pride in their craftsmanship and products were of a simpler nature in which form followed function. In that respect, Morris is, quite rightly, regarded by many as a pioneer of modern design.

Early Life

Morris was born in Walthamstow, then a village on the outskirts of London, into a privileged family. He was one of nine and the eldest son. His father was a partner in a brokerage firm in the City of London, and was successful enough to move his family into a large house, Woodford Hall, when Morris was six years old. He was a precocious child and was by that age already avidly reading the novels of Sir Walter Scott (1771–1832), among others. Living close to Epping Forest, he also enjoyed riding his pony, sometimes wearing a toy suit of armour, and exploring the flora and fauna of the forest.

In 1847, Morris's father died and the family had to move to more modest accommodation, Water House (now The William Morris Gallery), also in Walthamstow. At this time, Morris was enrolled at Marlborough College. By his own admission, he learned very little from the school's regular curriculum, but set himself the task of learning through exploring the history and topography of the area. The Reverend F.B. Guy taught Morris as a private pupil for nearly a year

after leaving school. In 1853, Morris entered Exeter College, Oxford University, determined to become a clergyman in the Anglo-Catholic faith. Morris, brought up as an Anglican, had become interested in Anglo-Catholicism under the influence of a tutor at Marlborough. One of his fellow theology students at Oxford was the artist Edward Burne-Jones (1833–98), who became his lifelong friend. The Oxford Movement, which was centred on academics and intellectuals at Oxford University and argued for the reinstatement of lost Christian traditions, profoundly influenced them and three other fellow students.

In 1829, the Roman Catholic Relief Act was passed, which allowed Catholics many privileges denied to them since the Reformation nearly three hundred years before, most notably the right to hold public office. In the aftermath of this act, a number of prominent Anglicans began to reassess the relationship between Anglicanism and Roman Catholicism. They published a series of 'Tracts' between 1833 and 1841, in which they sought changes to the ceremony of the Anglican service so that it might include, for example, the Eucharist. Because of these, members of the Oxford Movement also became known as 'Tractarians'. One of the main protagonists of the movement was John Henry Newman (1801–90), who became disillusioned with the pace of reform and became a Roman Catholic, eventually becoming a cardinal.

John Ruskin and A.W.N. Pugin

John Ruskin (1819–1900) was the pre-eminent scholar and writer on art, design and architecture in the nineteenth century. Aged just 24, he became the primary supporter of the landscape painter J.M.W. Turner (1775–1851), and later the group of radical artists known as the Pre-Raphaelite Brotherhood. Like Morris, he lamented the malaise in the time's design and architecture, in particular the over-ornamentation of products and buildings, the dominance of the Neoclassical style and the adverse effect design and manufacture was having on society through the division of labour. What Ruskin proposed was a return to the Gothic style, as advocated by his near contemporary, the architect and designer Augustus Welby Northmore Pugin (1812–52). Pugin had written several papers on the evils of Classical architecture, arguing that it was derived from a pagan

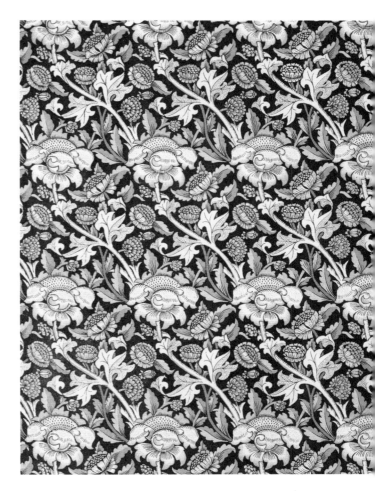

tradition and suggesting Gothic as a more suitable style in Northern Europe. In effect, what Ruskin and Pugin both advocated was a return to the medieval values of design and craftsmanship. Ruskin's writings included *The Seven Lamps of Architecture*, published in 1849, and the three-volume *The Stones of Venice*, published in 1851–53. His notion of Gothic differed somewhat from Pugin's, in that Ruskin preferred the Venetian style of medieval Gothic architecture, rather than the conventional Gothic of Northern Europe.

Pugin was only 40 years old when he died, exhausted by the prodigious output of his career, most notably the designs for the Houses of Parliament in London. His swan song was the Medieval Court at the Great Exhibition in 1851, at which he was almost single-handedly trying to arrest and reverse the effects of industrial mass-

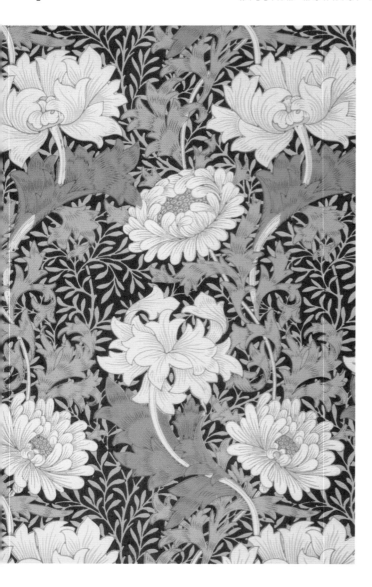

delighted his close-knit circle of friends that included Burne-Jones. He was disappointed not to find the religious fervour he expected at Oxford and, due to this, he was drawn towards more secular aspects of design. In his later stained-glass designs for churches, there is a more humanistic quality than a spiritual one. Although he read Newman and other Tractarians, he was more attracted to the writings of Geoffrey Chaucer (*c.* 1343–1400), Thomas Malory (d. 1471) and Alfred Lord Tennyson (1809–92), the common theme being the romanticism of the medieval period. The Bodleian Library at Oxford also provided him with a useful resource for the study of original medieval manuscripts. Morris joined the 'Birmingham Set' set up by Burne-Jones and others from the city studying at Oxford in the 1850s. Their evening meetings discussed both the visual arts and literature and, in particular, how they might be used in social reform as well as aesthetics. To this end, the group visited many churches in the villages around Oxford.

Morris came of age while at Oxford and inherited the sum of £900 per annum (approximately £60,000 today). Both he and Burne-Jones had by this time abandoned their plans to enter the Church. Apart from disillusionment with the Church, they had both attended some of John Ruskin's lectures, in which he advocated the naturalism of the Pre-Raphaelite Brotherhood. Their approach was in direct contrast with the manner of painting espoused by the Royal Academy. For the Brotherhood, the malaise in painting occurred during the High Renaissance era of Raphael (1483–1520), and they sought a move back to the more naïve work of the early Renaissance masters such as Fra Angelico (1395–1455). They were heavily criticized by the establishment, but it was Ruskin who championed their cause, adding considerable weight both as critic and patron. Morris and Burne-Jones saw the work of the Brotherhood at first hand in a gallery in Oxford. This was a revelation to them, as it was imbued with all the qualities they sought in their own vision for the future of art. They had also visited a number of Norman and Gothic churches in northern France, including the magnificent cathedral at Rouen. Persuaded by Ruskin's writings on the nature of Gothic and inspired by the use of medieval motifs in painting, both Morris and Burne-Jones saw their future in art and design, committed to arresting what they and others saw as a declining aesthetic.

produced design. These ideas were instrumental in creating the Gothic Revival, which dominated the second half of the nineteenth century and in which Morris played a key part.

Oxford University

While at Oxford, Morris demonstrated a great deal of physical energy, enjoying both rowing and fencing. He was also an eminent debater, full of passion and, at times, quite vociferous in his opinions, which

Apprenticeship

At the beginning of 1856, Morris graduated from university with a 'pass degree', and joined the Oxford-based architectural practice of George Edmund Street (1824–81) as an apprentice. Street was an enthusiast of the burgeoning Gothic Revival style, promoted by the Ecclesiological Society, of which he was an active member. It was the Ecclesiological Society that commissioned the 'model church' of All Saints Margaret Street in central London, built in 1850 to provide a template for brick-built Gothic Revival church architecture, a style seen again in St James the Less in London, built by Street in 1859. Morris only stayed with this practice for nine months, but it was during this time that he met Street's assistant architect Philip Webb (1831–1915). Webb financed a new monthly periodical called *The Oxford and Cambridge Magazine*, in which he and others contributed poems, essays and articles on various subjects such as aesthetics and social reform.

In the summer of 1856, Street moved his practice to London. Morris stayed with him until the autumn of that year, moving into lodgings with Burne-Jones in Bloomsbury, a fashionable area of London where the University of London had been established only 20 years before. It had been set up in direct opposition to the Oxford and Cambridge universities, as a more liberal establishment that welcomed non-Anglican and female students. Consequently, this area became known for its liberal and more socially aware population, a natural habitat for Morris, Burne-Jones and others of their ilk. It was also the area in which the Pre-Raphaelite Brotherhood was formed in 1848, which comprised the artists John Everett Millais (1829–96), William Holman Hunt (1827–1910) and Dante Gabriel Rossetti (1828–82).

Rossetti and the Pre-Raphaelite Brotherhood

Of the three original members of the Brotherhood, Rossetti was by far the most charismatic. Burne-Jones had organized a meeting with him in early 1856, which was also attended by Morris. At this time, Rossetti had effectively moved away from the other Brothers to pursue an interest in the medieval, while Millais and Hunt continued their interest in Ruskin's notion of 'following nature' as inspiration for their painting.

Rossetti persuaded Morris to take up painting and put architecture aside. He was also persuaded to start buying paintings in the Pre-Raphaelite style and purchased *April Love* by Arthur Hughes (1832–1915), which depicts a young woman in love and had been exhibited at the Royal Academy the previous year. At the exhibition, it was accompanied by a verse from Tennyson's poem 'The Miller's Daughter'.

Morris moved from his lodgings into Red Lion Square, still in the Bloomsbury district, where he began experimenting in woodcarving and clay modelling. His foray into painting turned out to be short-lived when he realized he was unable to accurately depict figures, an aspect that was to hinder some of his later design work.

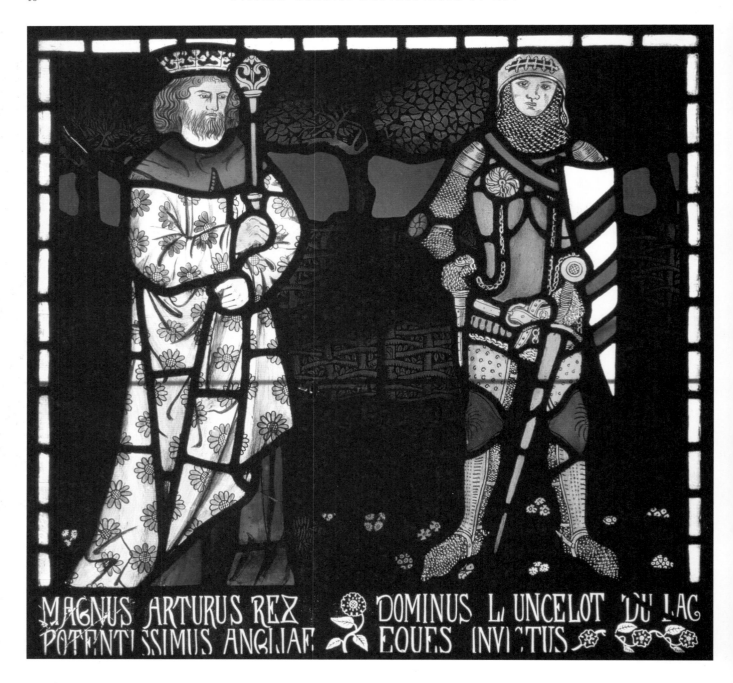

MAGNUS ARTURUS REX POTENTISSIMUS ANGLIAE DOMINUS LUNCELOT DU LAC EQUES INVICTUS

Rossetti was friends with the architect Benjamin Woodward (1816–61), who at this time was involved in the construction of the Natural History Museum in Oxford, and had designed the Debating Hall at the Oxford Union Society, both of which adhered to Ruskin's ideas of Venetian Gothic. In the summer of 1857, Rossetti, Burne-Jones and Morris went to Oxford to decorate the walls of the hall with medieval frescoes, Rossetti depicting scenes from Thomas Malory's *Le Morte d'Arthur*. They were joined by other artists, such as Arthur Hughes and Val

Prinsep (1838–1904). What they lacked in experience they made up for with enthusiasm, with Morris at his most ebullient, depicting scenes from the twelfth-century love story of *Tristan and Isolde*. Unfortunately, the walls had not been prepared properly and little remains of their brightly coloured scenes, including those painted by Morris.

One aspect of the Pre-Raphaelite Brotherhood paintings was the use of female models with red hair. This was most evident in Rossetti's pictures, who recruited a number of 'stunners', as he called them, in his line-up of sitters. From the time of the Brotherhood's foundation, Rossetti and his fellow Brothers called on Elizabeth (Lizzie) Siddal (1829–62) as a muse for their paintings, most famously as Millais' Ophelia. Another sitter was Jane Burden (1839–1914), who was later to marry Morris.

Jane Burden

Jane was born in Oxford to an impoverished family, her father a stablehand. In 1857, she was trying to make a name for herself as an actress, and was noticed on stage by Rossetti and Burne-Jones. They persuaded her to pose for them as a model for Queen Guinevere in their depictions for the Oxford Union murals. Both were captivated by her beauty, as was Morris, who later proposed to her (and she accepted) in the spring of 1858. She was not, by her later admission, in love with him, but decided that marriage to a young, upwardly mobile, fairly wealthy gentleman of taste was possibly her one and only opportunity for social climbing. Following their engagement, Jane was educated privately, at Morris's expense, in order to prepare her for life as a wealthy gentleman's wife. Her innate intelligence and creative ability was quickly demonstrated as she became proficient in foreign languages and at the piano too. It has been suggested by some that she may have been the inspiration for *Pygmalion*, an early twentieth-century play by George Bernard Shaw (1856–1950), in which a professor of phonetics makes a bet that he can train a Cockney flower girl to pass for a duchess.

The couple were married in April 1859 and moved into Red House in Bexleyheath, just outside of South East London. It was here that their two daughters Jane Alice (Jenny) and Mary (May) were born, in 1861 and 1862 respectively.

Red House

Described by Burne-Jones as the 'beautifullest place on earth', Morris commissioned his architect friend Philip Webb to design Red House (*see* below), taking its name from the colour of the bricks used. It was no coincidence that the spot he chose to build the house on was close to the route taken by medieval pilgrims out of London, as related in Chaucer's *Canterbury Tales*.

From the time of his engagement to Jane in 1858 to their marriage the following year, Morris and Webb travelled around the country and in

northern France, seeking ideas for Red House. The plans were completed by the time of the wedding, and the newlyweds moved in to the house in April 1860. The total cost of the build was £4,000, which came out of Morris's inheritance. The home was Webb's design; however, it still needed furnishing, which gave Morris his first opportunity to put his design ideas into practice.

Many of the ceilings, as well as the hall, stairs and landing, were decorated by Morris in abstract geometric patterns. Burne-Jones was commissioned to design stained-glass windows and to paint murals of medieval scenes of chivalrous deeds on the walls. Morris also designed and wove many of the textiles, such as tapestries and curtains and other soft furnishings. Webb too was kept busy designing furniture and fittings for the new house, much of it rustic and heavy in design so as to keep to a medieval aesthetic.

During the next few years, Burne-Jones and his wife Georgina (née MacDonald, 1840–1920) were frequent visitors to Red House, and other artists came to lend a hand with the furnishings and decoration. At this time, it was possible to take the train from London to the nearby village of Upton, where Morris would collect his guests in a horse and carriage for the last three miles of the journey, from which they could admire the open Kent countryside.

Morris, Marshall, Faulkner & Co.

While equipping and decorating Red House, Morris struggled to find the furniture and furnishings suited to his taste, and so he embarked on an enterprise to provide such products, founding the firm Morris, Marshall, Faulkner & Co. Its founders were Morris, Rossetti, Burne-Jones, Webb and another Pre-Raphaelite artist, Ford Madox Brown (1821–93), together with two of Morris's Oxford chums, the mathematician Charles Faulkner (1833–92) and the engineer Peter Marshall (1830–1900). It was affectionately known as the 'Firm'.

Their business premises were at Red Lion Square, where Morris lived prior to his marriage, leasing additional space over three floors, including a basement area in which a kiln was constructed for firing glass and tiles. Morris anticipated that their clientele would be a mix

of ecclesiastical and domestic. In the event, most of their early clients were the former, particularly as the Gothic Revival gathered momentum. In 1861, the Firm produced its prospectus, clearly outlining its aims of providing quality decorative arts using 'artists of repute'. In this regard, Morris was following the tenets of John Ruskin, who had also been appalled by the sacrificing of quality in the machine age of mass production. For him, and by extension Morris, not only were the products debased, but so too were the craftsmen whose livelihoods had been undermined by the Industrial Revolution and the division of labour.

The Firm had its first success at the 1862 International Exhibition, which took place at the South Kensington Museum. They created their own version of the Medieval Court (in homage to Pugin's 1851

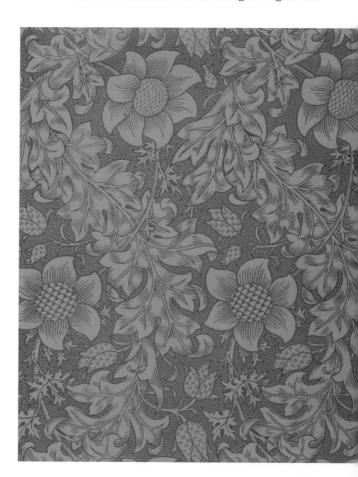

exhibition) and won two medals. The display featured pieces of furniture brought from Red House, but the most impressive of these was the stained glass designed by Rossetti, which led to the Firm being commissioned to supply windows for three newly built Gothic Revival churches. They also undertook secular commissions such as the *Tristram and Isoude* [sic] stained-glass windows (1862) for Harden Grange, the house of textile merchant Walter Dunlop, near Bingley in Yorkshire (*see* Morris's *King Arthur and Sir Lancelot*, page 10), or Burne-Jones's stained-glass series 'Chaucer's Goode Wimmen', which proved popular and was used in several decorative schemes, including the Combination Room at Peterhouse College, Cambridge.

It was also in 1862 that Morris created the first of his wallpaper designs, 'Trellis', which incorporated a floral motif intertwined within a wooden frame (*see* page 31). Webb drew the design for the birds, as Morris's figurative work was not sufficiently good. It was printed using woodblocks by the wallpaper print specialists of the time, Jeffrey & Co., with Morris taking an active part in the process.

The South Kensington Museum

The Great Exhibition of 1851 was a financial success, producing a surplus that facilitated the building of a new museum quarter in South Kensington, about half a mile to the south of the original site. The South Kensington Museum (later to become the famous Victoria & Albert Museum) was opened in 1857 to celebrate and display industrial design, to inspire and educate the public as well as designers. In the following decade, most of the scientific aspects had been moved to other premises, leaving the museum to concentrate on applied design, both practical and decorative. The museum also incorporated the Government School of Design. A number of designers and theorists were instrumental at this time in changing attitudes to design in mass production, including Owen Jones (1809–74), who wrote the seminal work *The Grammar of Ornament* in 1856, and his protégé Christopher Dresser (1834–1904), who, like Morris, was a key player in the development of a 'modern' style. Dresser, however, chose an alternative route to this 'modern' style by developing an Anglo-Japanese aesthetic.

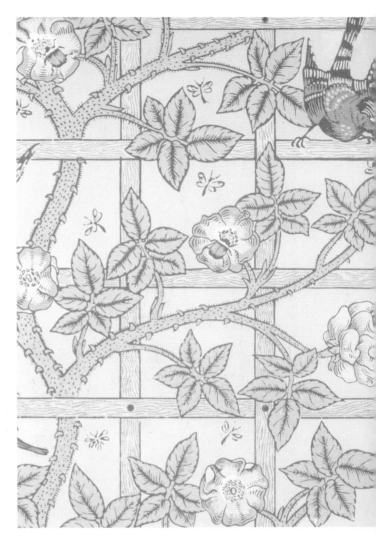

In 1867, the Firm were commissioned to decorate and furnish the Green Dining Room at the South Kensington Museum, which greatly enhanced their reputation. The scheme of blue and green provides a tranquil setting, but with decorative details that also provide interest. The cornice frieze at the top of the wall depicts a repeating pattern of a dog chasing a hare, while lower down, Burne-Jones designed a series of panels depicting astrological motifs. There are also three stained-glass panels and a ceiling decorated to a design by Webb. The work took about three years to complete and gave Morris a sense of how to organize a project of this scale, instead of the rather ad hoc approach used at Red House.

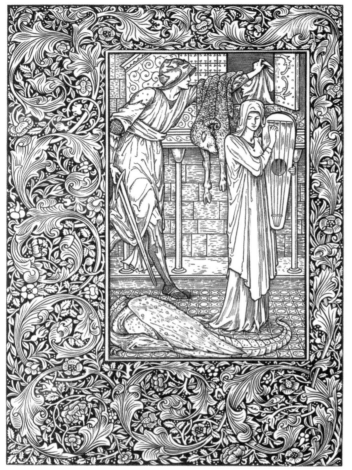

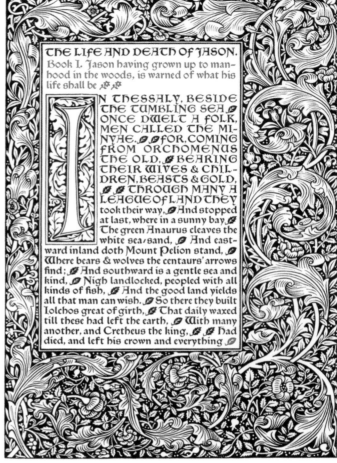

Writing

An avid reader in his youth, it seems natural that Morris would turn his creative talents to writing. His influences were eclectic, from the medieval Chaucer and Malory to the nineteenth-century Romantics such as John Keats (1795–1821) and Tennyson; from novelists Walter Scott and Charles Dickens (1812–70) to social thinkers of his own age such as Ruskin and Thomas Carlyle (1796–1881).

Morris's first work of note was a collection of poems published in 1858 under the title *The Defence of Guenevere and Other Poems*. The main poem is written in sharp contrast to the medieval poetry of Tennyson, in that the latter moralizes on Guenevere's behaviour, perhaps in line with

the chivalric requirements of the Poet Laureate. Morris's approach was rather different, depicting Guenevere in defiant mood. Needless to say, the critics were by and large negative in their reviews, which may account for the more traditional line adopted by Morris in his subsequent work. In fact, he did not publish again until 1867, possibly because of a combination of the negative reviews and his commitments to Red House and the Firm.

This next work was an epic poem, *The Life and Death of Jason* (*see* 1895 Kelmscott edition, above), which despite its title actually gave centre stage to the female protagonist, Medea, who helped Jason in his quest for the Golden Fleece. The story was used as a motif by the Pre-Raphaelite artists. The following year, in 1868, Morris began writing a

series of 24 stories called *The Earthly Paradise*, using different voices to relate a series of tales not unlike Chaucer in *The Canterbury Tales*. This book brought Morris literary fame, but the stories are rather melancholic, reflecting his own pain at the breakdown of his marriage.

Queen Square Premises

By 1864, the stress of commuting between Red House and Red Lion Square to manage the business was taking its toll, and Morris decided to leave his country home and take new premises in Queen Square, Bloomsbury, to provide a shop, workshops and living accommodation on the top floor, living there until 1872. Jane moved back to London with him and began to move within the social circles that included Rossetti, with whom she was later to have an affair.

Philip Webb continued designing furniture for the Firm, developing a range of 'Sussex' chairs, a light form of dining chair using a turned wooden frame supported by simple legs and struts and a rush seat (*see* the interior of Wightwick Manor, Staffordshire, right). This range included three-seater settles and corner chairs, and proved very popular well into the twentieth century. Webb also designed more elaborate settles, upholstered armchairs, tables and cabinets for the Firm.

Meanwhile, Morris was designing and publishing more wallpapers: 'Daisy' in 1864 (although this was actually designed in 1862, *see* page 30), 'Fruit' (also known as 'Pomegranate') in 1866 (*see* page 32), 'Larkspur' in 1872 and also 'Jasmine' the same year (*see* pages 36 and 35 respectively; Burne-Jones used the intricate and delicate 'Jasmine' pattern in his own home). Morris also developed a similar design in a printed fabric called 'Jasmine Trellis', one of many he was to create in his career (*see* page 74). As well as being prolifically creative, Morris enjoyed being in the shop, meeting his clientele and helping them with design suggestions.

Marital Problems

The move back to London was critical for the relationship between Jane and William Morris, whose marriage was already under strain. Morris

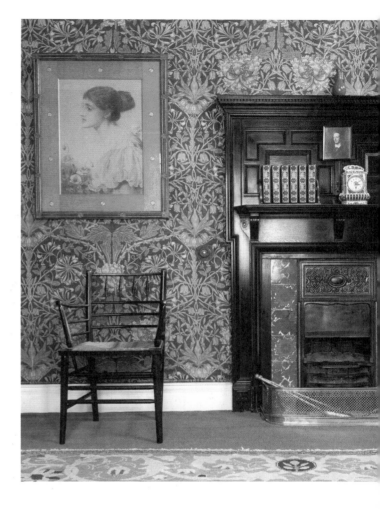

had a tendency to be bad-tempered and irascible, which was upsetting for the rather delicate Jane, who was ill-equipped to deal with this. Meanwhile, she was drawing closer to another man, Rossetti, with whom she had always secretly been in love, and with whom she corresponded without her husband's knowledge. In 1860, Rossetti had married his long-time companion and muse, Lizzie Siddal, but within two years, she had died from a laudanum overdose, possibly deliberate. The guilt-ridden Rossetti, who was also a chronic drug addict by this time, turned to Jane, or Janey, as he called her, for comfort and solace. Because of the social conventions of the time, which required Morris to turn a blind eye or face scandal and the ruin of Jane in society, it's difficult to be precise about when the affair started. It is known that in 1865, Jane posed for Rossetti for a series of drawings and photographs

at his house in Cheyne Walk, Chelsea, London, a habit that was repeated over the next few years. By 1869, the stress of the affair had taken its toll on Jane, and Morris took her away for rest and recuperation to a spa in Germany. During this time, she and Rossetti corresponded regularly and on her return to England, she spent a month at a cottage in Sussex with Rossetti, who was surely by now her lover.

The Icelandic Sagas

Following the loss of his wife to another, Morris became more absorbed in his work, and in 1868, began to translate Norse legends with a Cambridge scholar Eirikr Magnusson (1833–1913), which culminated in the publication of *The Saga of Gunnlaag* and *The Grettis Saga* in

1869. Morris also began to weave some of this folklore into his own poetry; for example, his poem 'The Lovers of Gudrun', which is included in *The Earthly Paradise* (*see* above, pages from the 1896/97 Kelmscott Press edition), was adapted from *The Laxdaela Saga*.

The Icelandic Sagas provided Morris with an emotional release for the pent-up anger, resentment and sorrow he was feeling at this time. Unlike the Arthurian legends that had previously inspired him, these tales are much grittier, more fact-based and certainly more relevant to Morris's life and therefore poignant. For example, the *Laxdaela Saga* tells of a love triangle in which there are no winners; while *The Grettis Saga* relates the tale of an overweight outlaw, who is heroic but also at times feckless and often bad-tempered, traits that would resonate with Morris himself.

In order to understand the relevance of these sagas, Morris decided to
visit Iceland in July 1871, taking Magnusson and his business partner
Charles Faulkner with him, returning at the end of August. The majesty
of the volcanic landscape at once captivated Morris, but he was equally
impressed by Iceland's pre-industrial society, in which he saw a more
egalitarian attitude to work and hardship. This was later to provide
inspiration for his own socialist cause.

Kelmscott Manor

Before departing for Iceland, Morris entered into an agreement with
Rossetti on a lease for a country house in Gloucestershire called
Kelmscott Manor. This seventeenth-century property was built close
to the upper stretches of the River Thames using local stone, and its
unspoilt, rustic exterior appealed to Morris in particular. For him, it was
an organic house that blended perfectly with the surrounding land and
village. Nevertheless, he spent very little time there until after 1874.
Instead, Rossetti used it for his liaison with Jane, the house having the
relative obscurity from society to afford a scandal-free relationship.
They spent much of the summer of 1871 there while Morris was away
in Iceland, and continued to see each other at various times up until
1874 when Jane ended the affair because of Rossetti's increased
paranoia and failing health due to drug abuse.

After the affair had ended, Morris and Jane continued living together,
spending their time between Kelmscott and their new London home,
Horrington House in West London, having moved from Queen Square in
1872. He continued to design wallpapers, 'Vine' in 1873 (*see* page 37)
and 'Lily' (*see* page 39) the following year, which he used in the bedroom
at Kelmscott Manor. It appears to have been a design particularly well
suited to bedrooms, since the Burne-Joneses also used it in theirs. In
1873, Morris designed his first chintz print for textiles called 'Tulip and
Willow', possibly inspired by time spent in Kelmscott's natural setting.

Morris & Co.

From the time of its inception, the partners in Morris, Marshall,
Faulkner & Co. took a dwindling part in its activities, with the
exception of Burne-Jones, who played a vital role in the stained-glass

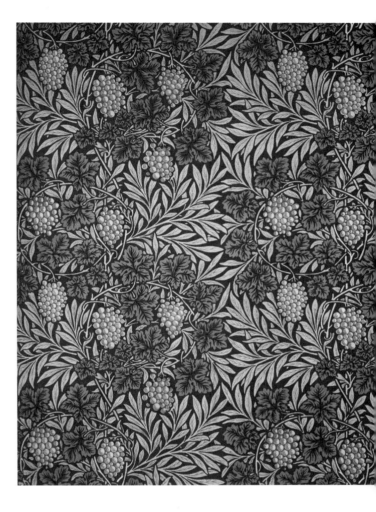

designs in their early work. As the Firm's client base became less
ecclesiastical and increasingly domestic, Morris decided to dissolve
the old partnership and Morris & Company was founded in 1875, with
himself solely in charge. There was little disagreement or animosity
about this decision from the other partners, with the exception of
Ford Madox Brown, and the Firm continued much as before. In his
premises at Horrington House, Morris set up a dye house, as he
disliked the aniline dyes commercially available, which he found
bold and rather garish. However, he quickly discovered that he was
unable to produce the quantities of natural dye required to meet the
increasing demand for his designs. His textile chintz design 'Tulip
and Willow' was a prime example. In December 1873, the design
was printed by Bannister Hall, a leading textile printer in Preston,

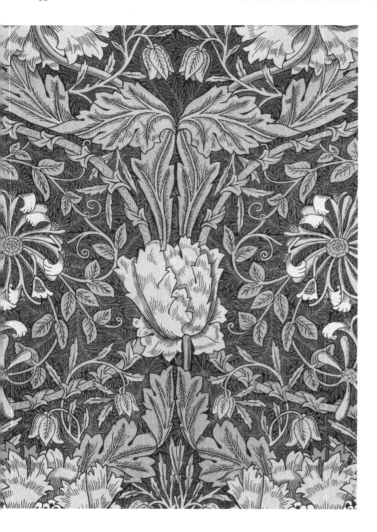

the very complex design of 'Honeysuckle' from 1876 (*see* page 79). Wardle exhibited this particular fabric under his own name, in the 'Indian' section of the 1878 Paris Exposition Universelle. It is significant to note that, at this time, Morris was moving away from more traditional floral motifs to a highly stylized form of decoration and pattern-making. One example of this is 'Snakeshead' designed in 1876, very much based on Indian design, possibly influenced by Wardle's pattern books, or in deference to Owen Jones, whose *Grammar of Ornament* was becoming an influential reference book for designers.

Expansion

In the mid-1870s, Morris began building on the earlier successes of his wallpaper range. In 1874, he designed 'Acanthus' using a large motif and 15 different colours, the most to date (*see* pages 40 and 41). The design was based on motifs that Morris was using in his calligraphy and illuminated manuscripts at the time, its bold line and intricate leaf veining a testament to his skills as a draughtsman. Another design called 'Pimpernel' followed in 1876 (*see* pages 44 and 45), and both 'Pimpernel' and 'Acanthus' were printed by Jeffrey & Co. on a heavier stock than previously used. Because of the heavier paper and the number of blocks required for printing these intricate designs, they were expensive, retailing at 16 shillings a roll (about £60 today). Morris used 'Pimpernel' in his dining room at Kelmscott Manor.

At the same time, Morris & Co. expanded their range of domestic furnishings to include embroidered wall hangings, woven furnishing fabrics, carpets and rugs. The range included ceramic tiles, which they had been designing since 1863, as well as a limited amount of tableware. Furniture design and production continued under the direction of Philip Webb, with very little being added to the range until after 1890. In 1877, the Firm opened a new showroom in central London's Oxford Street, which had become a popular shopping area for the middle classes. Here, people could buy wallpapers and fabrics to create their own decorative schemes. Towards the end of the 1870s, Morris became less involved with the running of the Firm as he spent increasing time pursuing his interest in politics.

Lancashire, using Prussian Blue, a commercially available synthetic dye. Morris felt the subtlety of his design had been lost, since indigo, a natural plant dye, was his preference.

It was not, however, until 1875, when he contacted Thomas Wardle (1831–1909, brother of the Firm's manager George, 1836–1910), who was a dye maker with his own factory in Leek, Staffordshire, that he found someone who could supply both the quantity and quality of natural dyes that Morris needed. The two men worked together tirelessly to find the right sorts of colours using plants. It was Wardle who managed to create the right process for making indigo, and by 1878, he was printing 14 different designs for Morris & Co., including

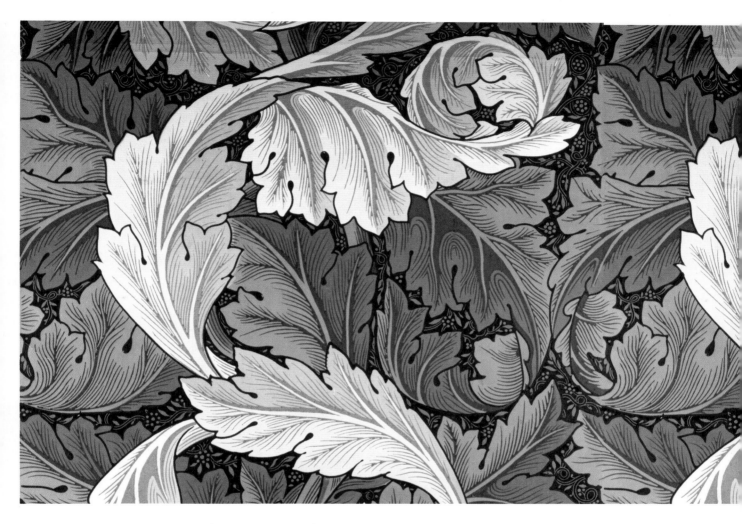

Politics

Morris was inclined to be socialist by nature, and so he felt unable to make a significant difference to the political landscape of Britain in his early career. However, a number of factors emerged in the 1870s that persuaded him to become more politically active after 1876. Firstly, he had become acutely aware that it was only a minority of the population who could afford the products and services of Morris & Co. He began resenting his own customers and started to rail against his role in satisfying their materialism, frowning at what he stated as 'spending his life ministering to the swinish rich'. Secondly, his travels to Iceland in 1871 and again in 1873 had made him aware of a grinding poverty that existed, which he attributed to the inequality of classes. Thirdly, and perhaps most significantly, Morris had become disenchanted with Liberal party politics under its leader William Gladstone (1809–98). In its early years, Liberalism had promised and delivered much for the benefit of ordinary people – the Trade Union Act 1871, for example, which made unions legal for the first time. However, Morris became disillusioned with Gladstone's opposition to what was generally referred to at the time as the 'Eastern Question', concerning the decline of the Ottoman Empire. Like many people of his time, Morris was appalled by Britain's inactivity in response to the Turkish massacre at Batak in 1876. As a result, he became much more politically involved, and was elected treasurer of the 'Eastern Question Association'.

At around this time, Morris's aesthetic principles had been offended by the insensitivity of architects such as the Gothic Revivalist George Gilbert Scott (1811–78), who he felt 'vandalized' churches by introducing aspects of design not inspired by medieval Gothic. Consequently, in 1877, after it was revealed what Scott was proposing to do at Tewkesbury Abbey, Morris formed the Society for the Protection of Ancient Buildings (SPAB). This organization flourished and was the forerunner of others that ensured that listed buildings were treated sympathetically. It continues its work today.

Kelmscott House, 1878

Horrington House, the Morrises' London home since 1872, was proving to be too small for the family's needs and in 1878, they moved into a much larger house called The Retreat. The house, still in the western suburbs, was closer to Central London, and Morris immediately renamed it Kelmscott House after his country home. Despite its classical Georgian character that was antipathetic to Morris's sensibilities, and original name, which Morris likened to an asylum, he remained here until his death in 1896. One aspect of the house that he did enjoy was its close proximity to the River Thames, and on at least two occasions, he made the journey by rowing boat with his family from here to the 'Manor'.

The move also meant a new direction for Morris's design work, the weaving of carpets and textiles. By this time, he was satisfied enough with the range of wools made by Thomas Wardle to undertake such a venture. Morris's carpet designs, such as 'Tulip and Lily' (1875), and fabrics, such as 'Tulip and Rose' (1876), were, until this time, commercially manufactured by Heckmondwike Manufacturing Co. in Yorkshire, using dyed wool supplied by Wardle. In 1878, he employed the services of a French weaver called Louis Bazin to teach him the skills on a mechanical Jacquard loom that he had brought over from Lyon. This was set up at Queen Square, now available after the showroom premises had moved to Oxford Street. Morris set up his own loom in the coach stables at Kelmscott House and began making a range of small carpets and rugs that he called 'Hammersmith' after the house's suburban location. He also began to produce a range of woven textiles, beginning with 'Bird', inspired in

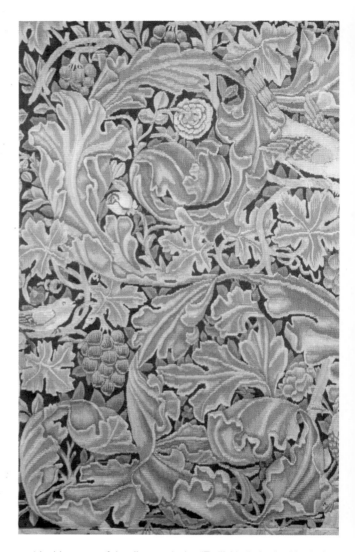

part by his successful wallpaper design 'Trellis' but also by his study of Italian fabrics at the South Kensington Museum. The 'Bird' design was used as a curtain as well as a wall fabric furnishing in the decorative scheme at Kelmscott House.

Merton Abbey

The success of Morris's experiments in carpets and fabrics led him to begin a series of tapestries, which he considered the highest and most noble aspect of weaving. The first of these was 'Acanthus and Vine', woven at Kelmscott House in 1879. The exercise took him over 500

hours to execute, and when complete, was referred to by Morris and his family as 'Cabbage and Vine' (*see* page 108). Morris also became interested in producing some hand-knotted carpets as well as the machine-woven ones on his Jacquard looms. To facilitate the expansion of his business, Morris began employing weavers and, having outgrown the Queen Square premises, eventually decided to relocate his manufacturing base elsewhere.

In 1881, Morris transferred his operation to Merton Abbey in Surrey, a former printing works about nine miles south of central London. It was semi-rural in its location, making it a pleasant working environment, close to the River Wandle, a tributary of the Thames, which provided water of the right quality to make madder (red) dye. Being a rural location, it had one drawback in terms of its accessibility to London, so Morris furnished a couple of rooms in which he stayed if he finished his work too late to make the journey home. This was to be one of the most energetic periods of his life. From 1881 to 1883, he patented no fewer than six designs for woven fabrics, six for printed textiles, including the popular 'Strawberry Thief' design (*see* page 88), and another two wallpaper designs. The wallpapers continued to be printed by Jeffrey & Co., but the textiles were printed or woven in the new premises at Merton Abbey, together with the tapestries and hand-knotted carpets.

The water from the River Wandle was found very suitable for the dye-making process Morris used at Merton. The method most often used was the indigo discharge process, in which the fabric is totally dyed in large indigo vats and the pattern is made in this, using bleaching agents. Having 'fixed' the white part, madder and yellow are printed on to the fabric, retaining their colour on the white areas, but producing green, purple and other variants where they are superimposed on to the indigo. The printed fabric was then washed in soap at a high temperature and laid out in the fields to dry. Some of the designs produced at this time were named after rivers of England, including 'Wandle' (*see* page 90).

Stained-glass design and manufacture continued at Merton under the direction of Burne-Jones, who continued to design most of it. Furniture production continued at premises close to Queen Square

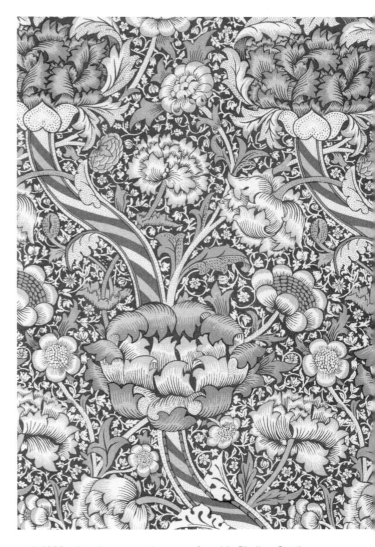

until 1890, when larger premises were found in Pimlico, South London. At this time, the chief designer for furniture was George Jack, (1855–1931), a pupil of Philip Webb. The Jacquard looms for weaving the textiles were also at Merton, while women and boys were employed to hand-knot carpets and rugs, as well as to undertake delicate tapestry work. Morris saw himself very much as a responsible and benevolent employer, and set up an apprenticeship scheme for boys, which also allowed them to live on the premises under the supervision of a housekeeper. In the early years of the workshops at Merton, Morris was on hand to supervise the work, but after 1884, he started to devolve this role to his assistant John Henry Dearle

(1860–1932), and later to his daughter May, as he became more involved in the socialist cause.

Morris the Radical

In a lecture given in 1881, Morris talked about the good fortune of his birth compared to many in London, who wanted 'employment which would foster their self-respect … and dwellings which would soothe and elevate them'. He was all too aware of the inequalities in Victorian England, and for him, the only hope for a fair society was a radical and even revolutionary sort of socialism. He was also inclined to believe that art left in the hands of the capitalists would degenerate and become 'sham art'. The social commentaries and novels of Charles Dickens earlier in the century had exposed the appalling living conditions of the poor, but other, lesser-known, more radical commentators such as Adolphe Smith (1846–1924), together with the photographer John Thomson (1837–1921), were using nonfiction to portray and capture life in the capital for the poor and disadvantaged. Some of these images, intended to shock the complacency and indifference of the middle classes, had a profound effect on people like Morris. Dissatisfied with Liberal politics and its leadership under Gladstone, he, along with many others, had recognized the need for a more radical politics that was not achievable by self-satisfying, middle-class politicians.

In 1883, Morris joined the Democratic Federation, founded two years earlier by Henry Hyndman (1842–1921), a socialist organization based on some of the principles of Karl Marx (1818–83), whom Morris had met while Marx was in exile in London. In essence, the Federation was seeking reforms in working practices, such as reduced working hours, the abolition of child labour and compulsory education for all. More radically, they were seeking the nationalization of the means of production, wresting control from the privileged classes. Morris became the Federation's treasurer in 1884 and helped finance their newsletter, called *Justice*. Regular meetings of the organization took place in the coach house at Kelmscott House. Despite his age (by now he was in his 50s), Morris was not averse to taking part in protest marches and speaking at open-air rallies, once being arrested and fined for his participation.

Coming from a privileged background, Morris had his detractors, most notably in the press, where he was described on the one hand as a traitor to his class and on the other as someone who should set an example by sharing the profits of Morris & Co. with his staff. In fact, Morris responded to the latter by paying a profit share to his key workers, but stopped short of making any of them partners in the Firm. Following a number of disagreements with Hyndman, Morris resigned from the Federation in 1884 and set up the Socialist League in collaboration with Marx's daughter Eleanor (1855–98), since Marx had died the previous year, along with Friedrich Engels (1820–95), the co-author of *The Communist Manifesto*, and Ernest Belfort Bax (1854–1926).

With his immersion in the world of politics, Morris became less and less involved with the running of the Firm, devolving work and responsibilities to his daughter May, who by this time was 21 years of age, together with his loyal and faithful business manager George Wardle and chief designer John Henry Dearle.

May Morris

May was taught embroidery as a child by her mother Jane, and in 1881 enrolled at the National Art Training School (later the Royal College of Art). By 1885, she had become director of the embroidery section at Merton Abbey. She and her father were keen to revive free-form embroidery as an art form. These pieces were very expensive because of the man-hours employed and could only be afforded by the wealthy patrons of the Firm. May was also very supportive of her father's political ambitions, joining the Socialist League, where she met her future husband Henry Sparling (1860–1924), secretary of the organization. Some work of May's (c. 1891–95) can be seen in the picture opposite, showing a pelmet on Morris's early-seventeenth-century oak bed, which displays his poem 'For the bed at Kelmscott', composed in 1891 and embroidered by May; the bed curtains were also embroidered by May.

Aside from her embroidery skills, May was also a designer in her own right, producing embroidery kits of different skill levels for sale to the public at the Morris & Co. showrooms. She designed the motif that would be printed on a linen ground with one corner section completed

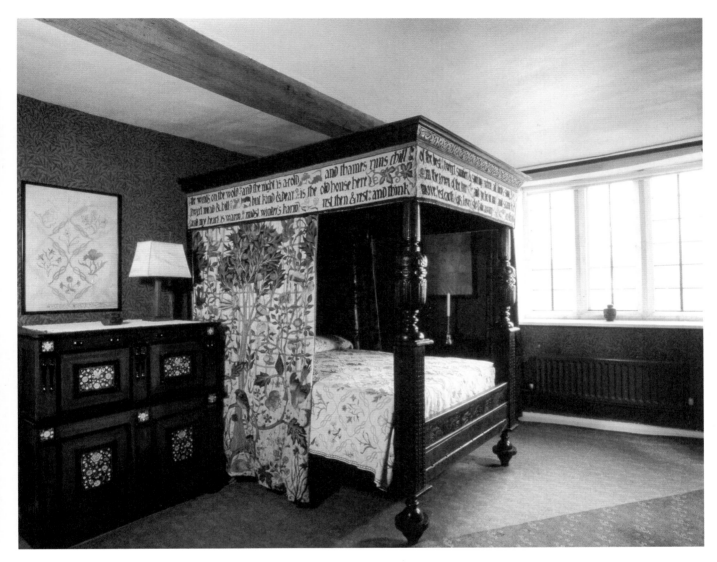

in silks as a guide for stitch type and colour. May was also involved in the Royal School of Art Needlework (now the Royal School of Needlework) before setting up the Women's Guild of Arts in 1907 as a reaction to the exclusion of women from the Art Workers' Guild, founded in 1884 and an entirely male preserve.

Arts and Crafts Exhibition Society

The Art Workers' Guild gave much-needed impetus to the design reforms Morris had been trying to achieve in the 1860s and 1870s,

namely the return to undivided labour in manufacturing and the evolution of an aesthetic suited to comfortable living. In essence:

*'Have nothing in your houses that you do not know
to be useful, or believe to be beautiful.'*

In 1887, a number of the Guild's members co-operated to set up the first Arts and Crafts Exhibition, which took place in London the following year. Exhibitors were influenced by Morris's approach to design, employing natural motifs in a restrained and disciplined

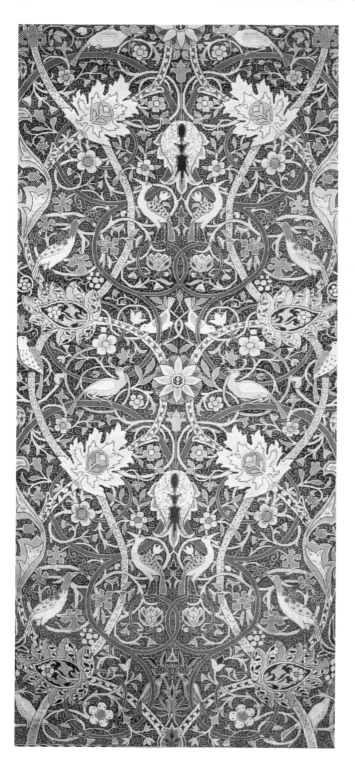

manner. The first president of the Exhibition Society was Walter Crane (1845–1915), who, like Morris, was a socialist and who made his contribution to social equality by using his skills as an illustrator to create colourful children's books. The Society's committee also included Morris, who, three years later, took over from Crane as president. At the first exhibition, Morris showed his latest textile designs, including the woven design 'Brocatel', although it is unclear whether Morris or John Henry Dearle actually designed the pattern. These first exhibitions witnessed the spread of the Arts and Crafts Movement in England, and by 1890, the Guild had over 150 practising members, including several who set up their own co-operatives, for example: C.R. Ashbee (1863–1942), who set up the Guild and School of Handicrafts; and William Lethaby (1857–1931), who founded the Central School of Arts and Crafts in London.

It was at the 1893 exhibition that William Morris exhibited his finest hand-knotted carpet, made for Bullerswood, the house of wool trader John Sanderson. The 'Bullerswood' carpet was one of two commissioned for the house (*see* page 120).

The Kelmscott Press

Morris loved medieval books and illuminated manuscripts, having seen these first-hand in the Bodleian Library while studying at Oxford. He had also started collecting them. According to his biographer J.W. Mackail (1858–1945), Morris purchased a fourteenth-century book, *The English Book of Hours*, for £400 (equivalent to £30,000 today). He had also written and designed his own books, such as *A Tale of the House of the Wolfings*, published in 1889 by Chiswick Press.

Renting a cottage close to Kelmscott House in London, Morris established his own printing presses based on medieval examples to produce copies of his poems and tales, together with some medieval classics such as Chaucer's *Canterbury Tales*, as well as the works of the nineteenth-century Romantics such as Tennyson and Samuel Coleridge (1772–1834). Encouraged by his close neighbour and friend, the typographer Emery Walker (1851–1933), Morris began printing books using hand-made linen paper and the deepest, most opaque black ink from Germany to print the pages, which were then bound in

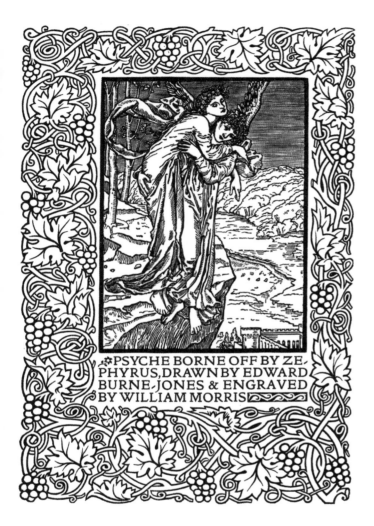

calf-skin vellum. Morris employed a master printer, William Bowden, together with Bowden's son and daughter, to help with the enterprise. However, Morris continued to supervise all publishing and even helped carve the woodblocks for printing.

The first publication by the Kelmscott Press was *The Story of the Glittering Plain*, published in 1891, a story written by Morris. Walter Crane was asked to illustrate the story, but Morris decided to print six copies of the book without them, the only copies ever made. He used a new typeface for the publication, 'Golden' type, which was his own creation, one of five he created specifically for the Kelmscott Press. The following year, Morris published *The Golden Legend*, with

illustrations by his old friend Burne-Jones. Their collaboration on the book *The Works of Geoffrey Chaucer* is generally accepted as the high point of the Kelmscott Press enterprise, with Burne-Jones creating 87 illustrations and Morris creating the 'Chaucer' font for the work, as well as cutting the woodblocks.

Apart from the medieval-inspired tales he published, Morris also used the Kelmscott Press for publications with a political message, such as the novel *News from Nowhere*, in which the central character dreams of living in a futuristic utopia, where there are no class divisions, no private property and everyone lives in an agrarian society of people who find pleasure in work.

The Kelmscott Press was never intended to make a profit, despite printing 18,000 volumes of over fifty different titles. For Morris it was a labour of love, his swan song. The books were expensive to produce and to buy, because they were intended to be savoured not just for the prose, but as objects of art in themselves?

Illness and Death

Soon after Morris established the Kelmscott Press, he was taken seriously ill. He was suffering from gout and also had kidney problems, which needed rest and convalescence. Despite being occasionally bedridden, he continued designing and even cut woodblocks in bed for the Kelmscott Press. He and Jane were also feeling the stress of looking after their elder daughter Jenny, who suffered from unpredictable epileptic seizures. Morris's illnesses were exacerbated by his tireless work as a political activist, which saw him speaking outdoors in all weathers. But these efforts and sacrifices would not go unrewarded, and he would have felt some satisfaction with the election of 1892 that yielded the first Labour party politician, Kier Hardie (1856–1915). This led to the setting up of the Independent Labour Party by Hardie, a key aspiration of Morris.

Morris continued to write new stories and poems that were published by the Kelmscott Press (some posthumously) and, following the death of Tennyson, he was offered the post of Poet Laureate, such was the eloquence of his writing. He declined the honour. He also worked on a series of tapestries with John Henry Dearle and Burne-Jones that were woven at Merton Abbey. Several versions of 'The Adoration' (*see* page 124) were produced between 1890 and 1907, each taking two years to weave and measuring five metres in length. Another design by the trio was for 'The Holy Grail' series for Stanmore Hall (*see* page 122), a private residence outside of North London. The series took four years to weave and cost the staggering sum of £3,500 (over £300,000 today).

Morris was concerned that he would not see the fruits of his labours on *The Works of Geoffrey Chaucer*. His health was deteriorating after 1892, and in January 1896, he gave his last political speech. In June of that year, he and Burne-Jones were together to see the first two copies of the 'Kelmscott Chaucer' back from the binders. That summer, Morris was advised to take a cruise to Norway to improve his health. Returning to London in August, he stayed at Kelmscott House and was frequently visited by his friends in the last weeks of his life. He died on the morning of 3 October, and a specially chartered train took his body to Kelmscott Manor in Gloucestershire for burial.

Many tributes poured in for Morris following his death. Robert Blatchford (1851–1943), the socialist commentator and writer, said of him: 'He was our best man, we cannot spare him, we cannot replace him.' Another commented that the cause of his death was simply 'being William Morris and having done more work than most ten men'.

Morris & Co. after Morris

William Morris had considered selling his business in 1890 so he could devote more time to his other passions, namely socialism and the Kelmscott Press. Instead, his own shrewd business sense persuaded him to allow two junior partners, Frank and Robert Smith, to buy into the Firm. John Henry Dearle, who had been hired as an assistant to work at the Oxford Street store in 1874, had proved himself invaluable to Morris & Co. Knowing the business from the bottom up, he had developed a talent not just for administration but also as a designer in his own right. On Morris's death, Dearle continued running Morris & Co. under the direction of the Smith brothers, who appointed him artistic director, and adding to the Firm's range of wallpapers and fabrics.

In 1905, when Henry Marillier (1865–1951), an academic design historian and expert on tapestries, was appointed managing director, Morris & Co. changed its name to Morris & Co. Decorators Ltd. Dearle continued as art director and chief designer. It was Dearle's death in 1932 that precipitated a gradual decline in the quality of the products and the company eventually closed in 1940.

Today, Sanderson & Co., a firm established in 1860, produce some of the designs created by William Morris.

The Morris Legacy

During his lifetime, Morris was best known by the public as a poet rather than a designer. Conversely, it is his legacy as a designer, rather than a writer, that continues to resonate today. In no small part, this was due to the design historian and writer Nikolaus Pevsner (1902–83), who wrote *Pioneers of the Modern Movement* in 1936, in which he portrayed Morris as the first of such. This popular book, which is

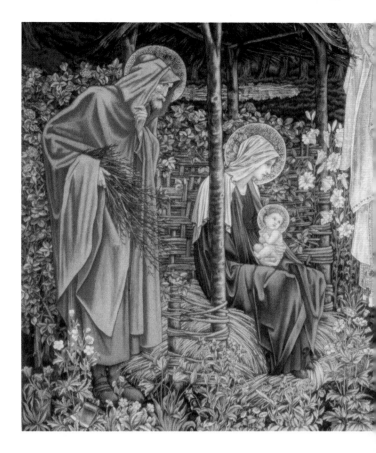

still being read and debated today, demonstrates that Morris sought a design aesthetic suited to the modern age, and one that was not elitist. Although he argued against Morris's rejection of the machine in manufacturing (which for Pevsner was a key component that meant good design could be affordable by all), he praised Morris for his social conscience when considering his designs, his use of a 'logical unity in composition', and the 'decorative honesty' of his work.

It is hard to add much to this appraisal of Morris the designer, but surely there can be few people, if any, who have been so gifted as a craftsman, writer of prose and poetry, translator, publisher, conservationist, businessman and radical politician. Above all, Morris was a visionary dreamer, who had an extraordinary ability to turn those dreams into reality. In his utopian novel *News from Nowhere*, Morris stated simply: 'If others can see it as I have seen it, then it may be called a vision rather than a dream.'

Wallpapers

One cannot think of William Morris without first thinking of his range of wallpapers, inspired by the flora and fauna of England and representing Morris's personal crusade against the rather garish and vulgar papers of the Victorian Age.

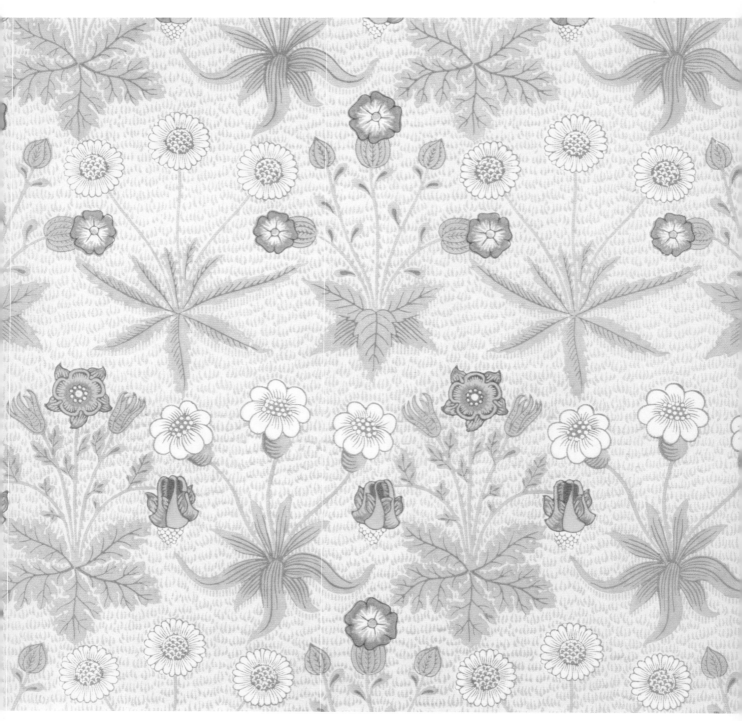

Daisy, 1862
Block-printed wallpaper • Private Collection

This delicate pattern of grass and leaves is interspersed with yellow daisies and other meadow flowers. It was available on three different-coloured grounds; the one shown here is a blue colourway.

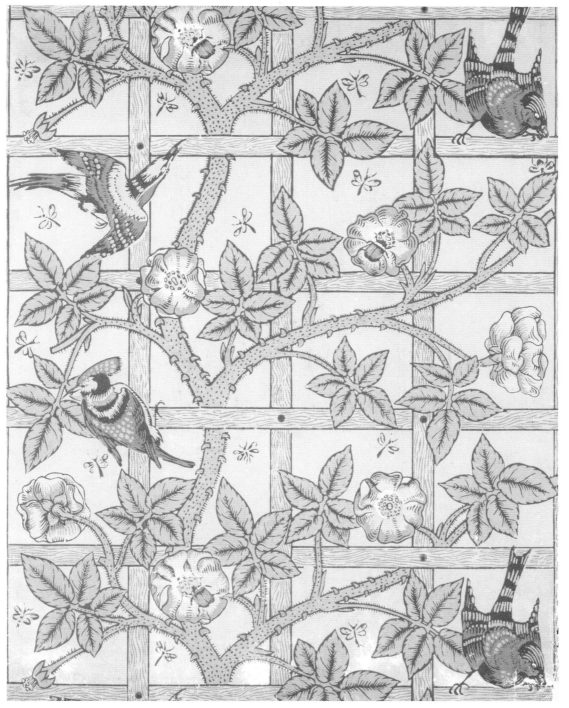

Trellis, 1862
Block-printed wallpaper • Private Collection

Generally regarded as the first William Morris wallpaper, there was an initial delay in production due to registration problems of the colours, which were resolved when Morris decided to use distemper colours in place of oil.

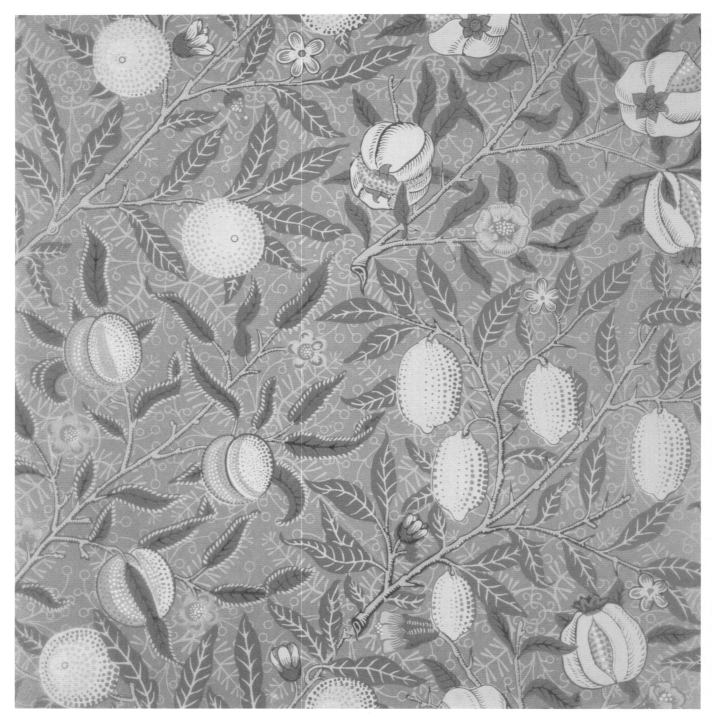

Fruit or Pomegranate, 1866
Block-printed wallpaper • Private Collection

'Fruit' continued to be a popular design well into the twentieth century. The diagonal design of this paper is very similar to that used in the Green Dining Room at the South Kensington Museum the following year.

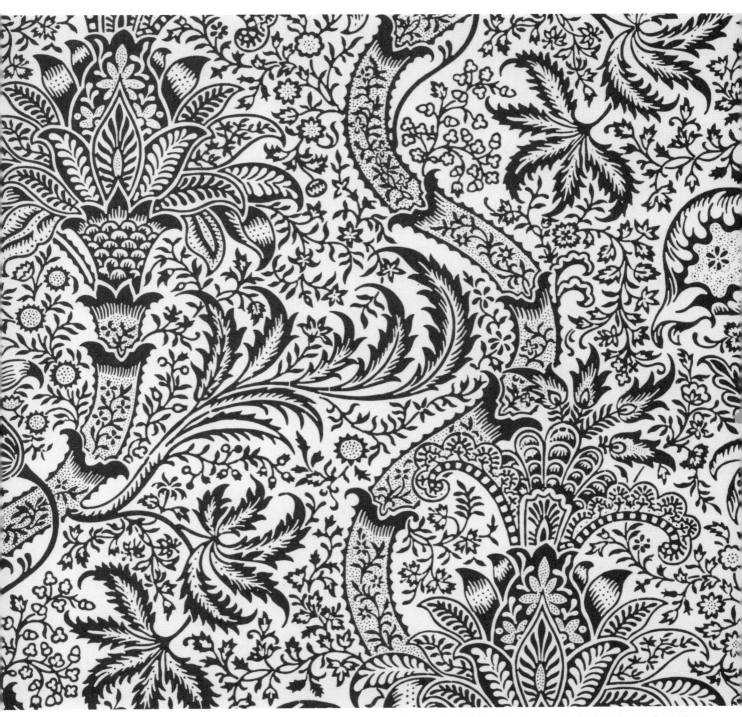

**Indian, 1868–70, possibly by
George Gilbert Scott (1811–78)**
Block-printed wallpaper • Private Collection/Stapleton Collection

Although published as a wallpaper by Morris & Co., 'Indian' was most probably designed by Scott rather than Morris. The design is an adaptation of an eighteenth-century Indian chintz paper.

Diaper, 1868–70
Block-printed wallpaper • Private Collection

Morris hated using two different wallpapers in one room, but exceptions were made, such as this one, which is unobtrusive and can be used with another paper with a more striking pattern.

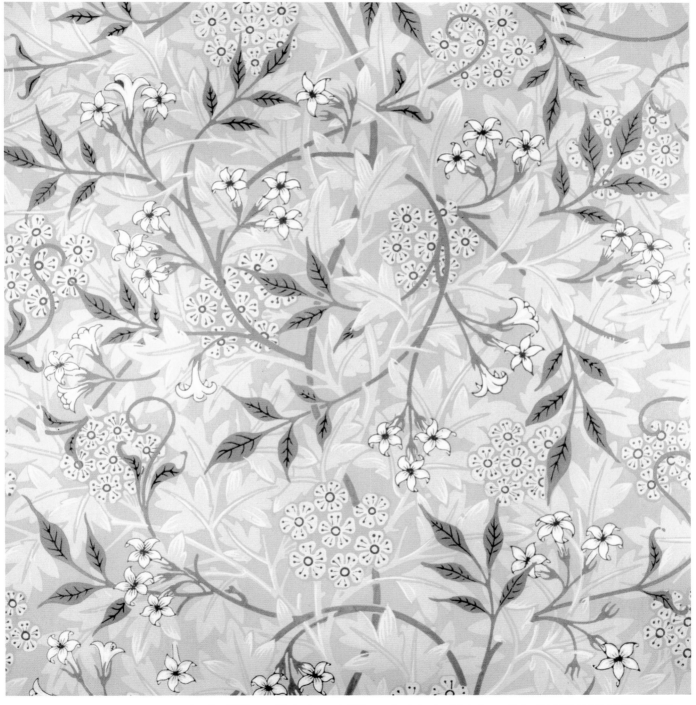

Jasmine, 1872
Block-printed wallpaper • Private Collection

The background of this complex design is printed all over with hawthorn leaves and a subtle blossom, which is then overlaid with a curving pattern of jasmine to provide a contrasting foreground.

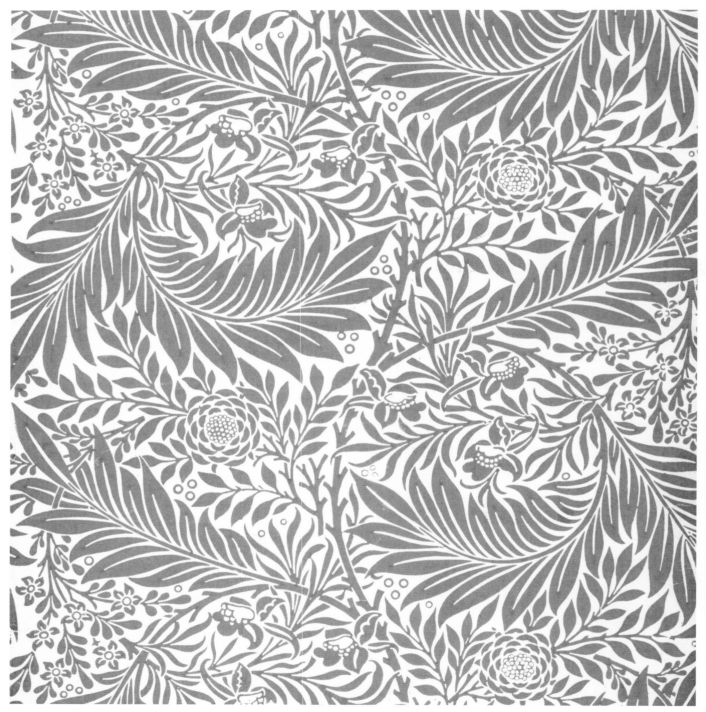

Larkspur, 1872
Block-printed wallpaper • Private Collection

This pattern was available initially as a monochrome wallpaper, as shown here, from about 1874. It was, however, more successful commercially after 1875, when it was overprinted with the flowers in blue and red.

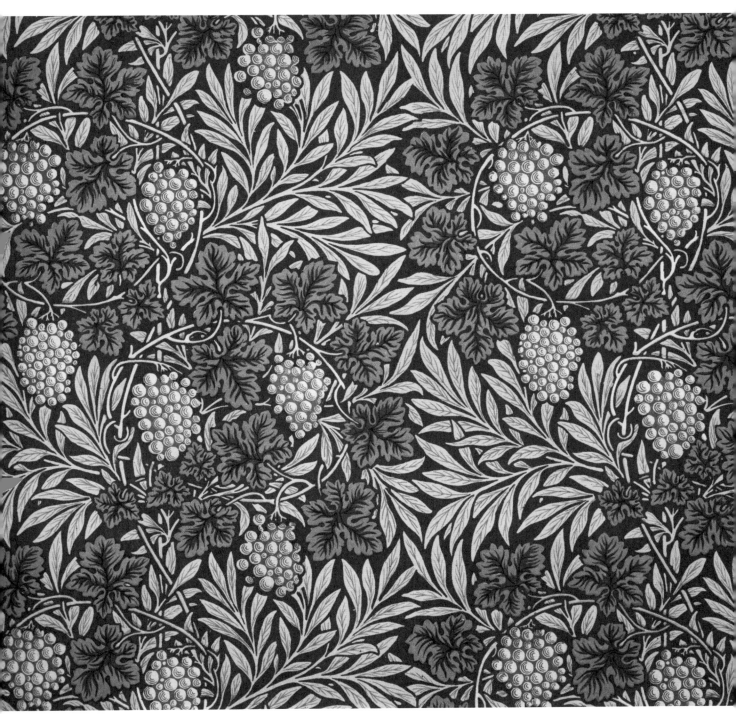

Vine, 1873
Block-printed wallpaper • Private Collection

This ordinary distemper print was later adapted by Morris to be printed on a gold, embossed ground, which added another dimension to the design.

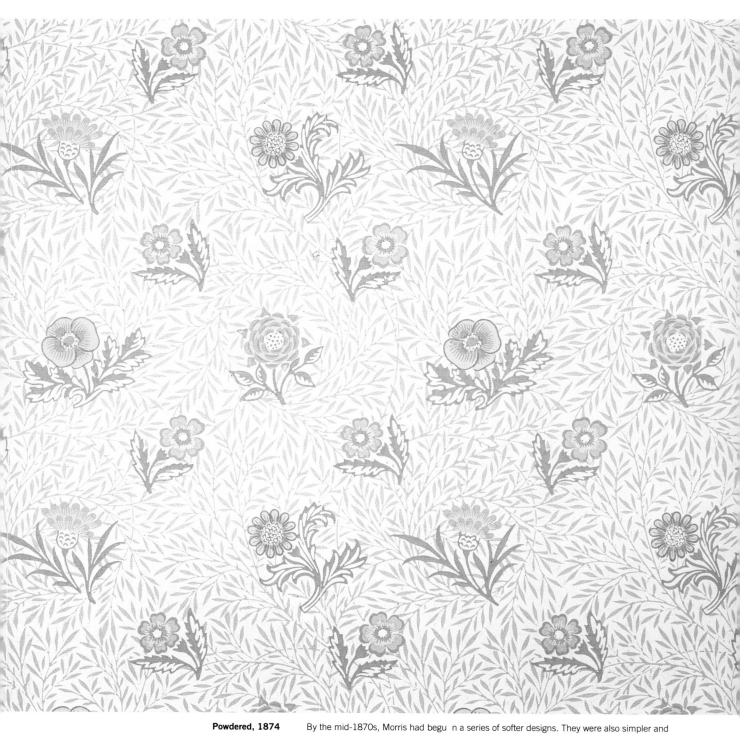

Powdered, 1874
Block-printed wallpaper
• Private Collection/The Stapleton Collection

By the mid-1870s, Morris had begu n a series of softer designs. They were also simpler and therefore less expensive to make and buy. Morris was determined to make his products available to as wide a public as possible.

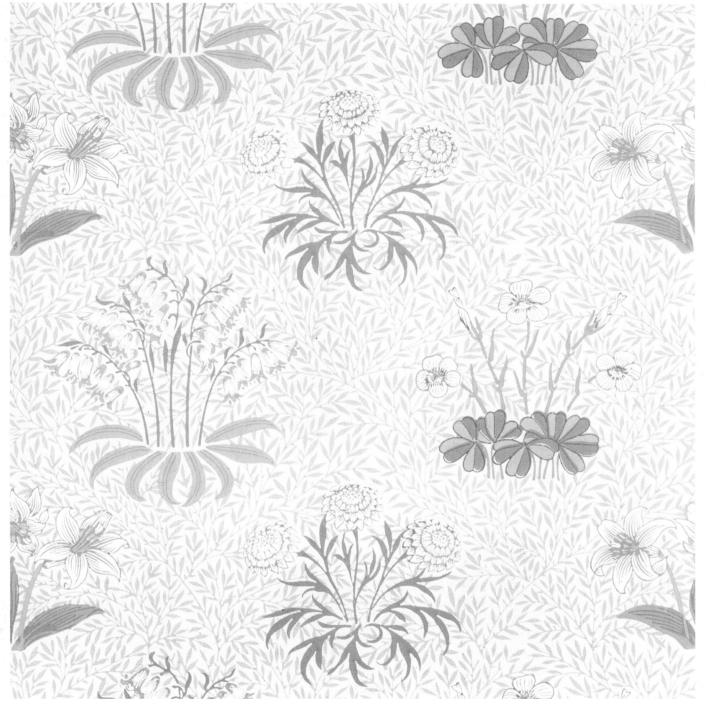

Lily, 1874
Block-printed wallpaper • Private Collection

The 'Lily' refers to the small, delicate lily-of-the-valley flowers in the design. Morris probably noticed these growing around Kelmscott Manor, along with the other wild flowers in this design.

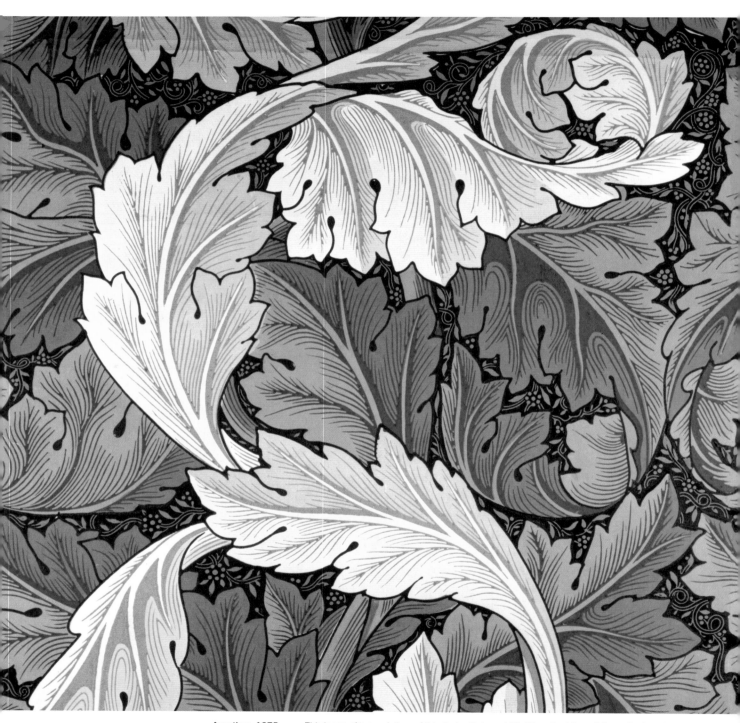

Acanthus, 1875
Block-printed wallpaper • Private Collection

This is one of two variations of this design that used 15 different subtle variations of colour, the most used to date in any of Morris's designs. Note the detailing of the veining in the leaves.

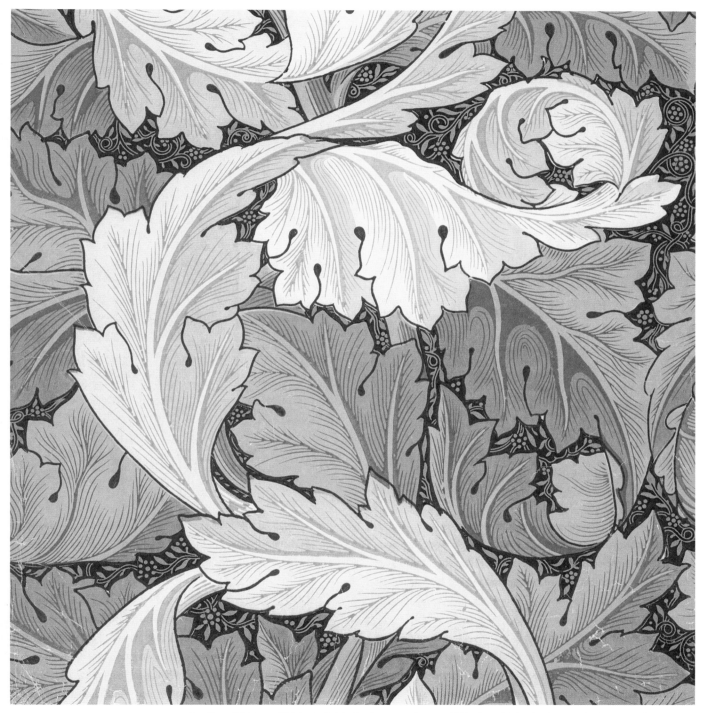

Acanthus, 1875
Block-printed wallpaper • Private Collection/The Stapleton Collection

This is the first design that uses a large motif, Morris explaining that it was well suited to small rooms because it was restful, lending itself particularly well to bedroom decoration.

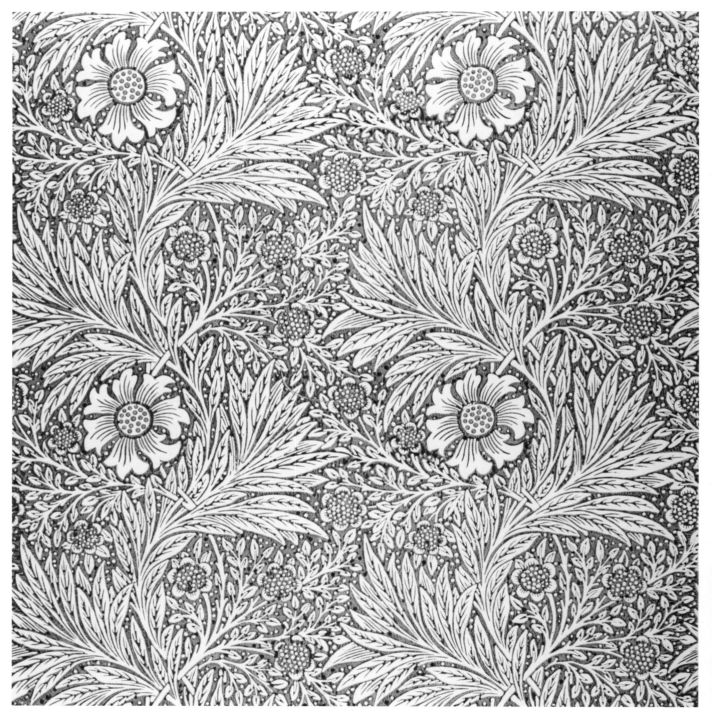

Marigold, 1875
Block-printed wallpaper • Private Collection

By the mid-1870s, Morris was beginning to simultaneously develop designs for wallpapers and printed textiles. 'Marigold' is a prime example of this development, the wallpaper being registered in February and the textile in April 1875.

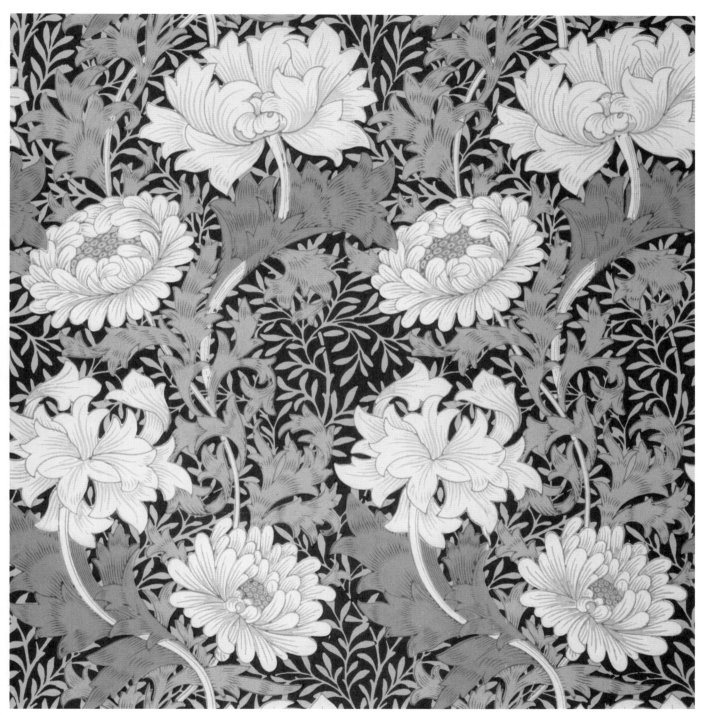

Chrysanthemum, 1877
Block-printed wallpaper • Private Collection/The Stapleton Collection

This delicate and subtle design was later embellished by Jeffrey & Co. to simulate gilded leather, for which the paper was stamped rather than printed, a technique that won the company a medal at the Paris Exposition Universelle of 1878.

Pimpernel, 1876
Block-printed wallpaper • Deutsches Tapetenmuseum,
Kassel, Germany

Another design that uses a very bold scrolling pattern and is not dissimilar to 'Acanthus', although the title actually refers to the small scarlet pimpernel flowers, which seem to give the larger flowers a three-dimensional quality.

Pimpernel, 1876
Block-printed wallpaper • Private Collection

In this version, the brown colourway allows the bright yellow pimpernel flowers to vie with the larger blooms. These tiny flowers prefer the shady areas of woodland trees, unlike their red and blue counterparts who like full sun.

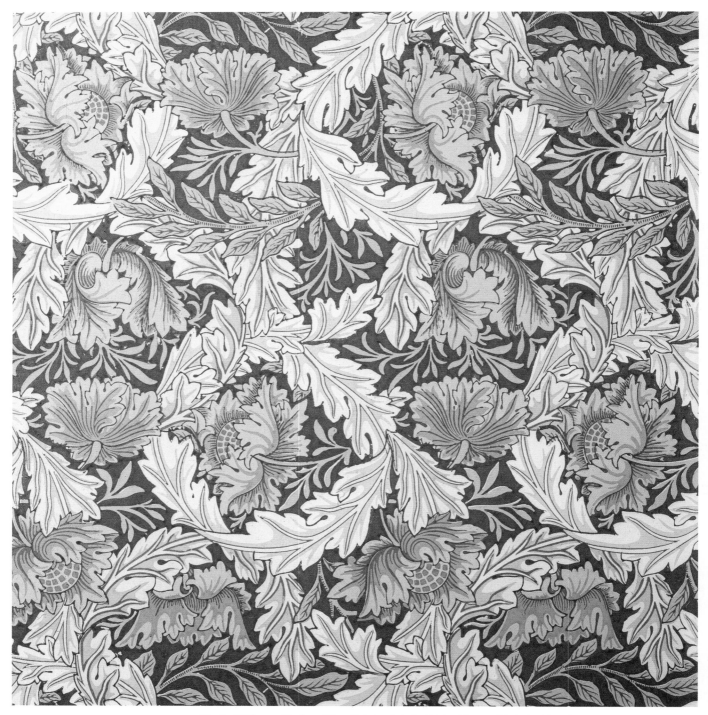

Wreath, 1876
Block-printed wallpaper • Private Collection

The firm of Barrett's in London's East End cut the woodblocks for this and most of the design transfers for Morris, ready for the printer Jeffrey & Co. (When a tapestry or carpet is woven, the design has to be transferred on to the back of the linen or cotton warp so the weaver has a pattern to follow.)

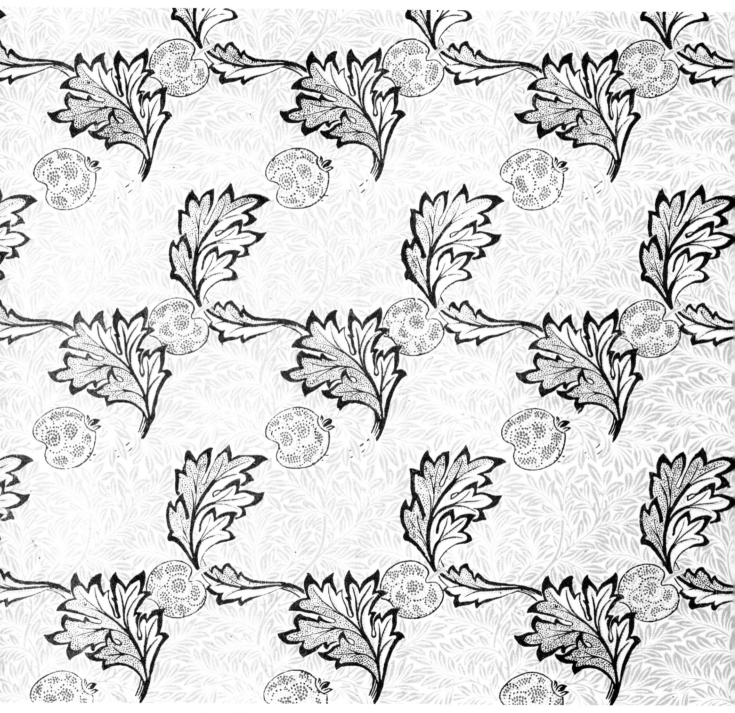

Apple, 1877
Block-printed wallpaper • Private Collection

A very stylized design of an apple with acanthus leaves interspersed. The acanthus is possibly the most widely used decorative motif, appearing in both Classical and medieval design and architecture.

Bower, 1877
Block-printed wallpaper • Private Collection/
The Stapleton Collection

The stylized honeysuckle blooms form a 'foliage' background, allowing the tulips, clematis and daisies to hold centre stage. Morris argued that for a pattern to work, it should have an 'unmistakable suggestion of garden and field'.

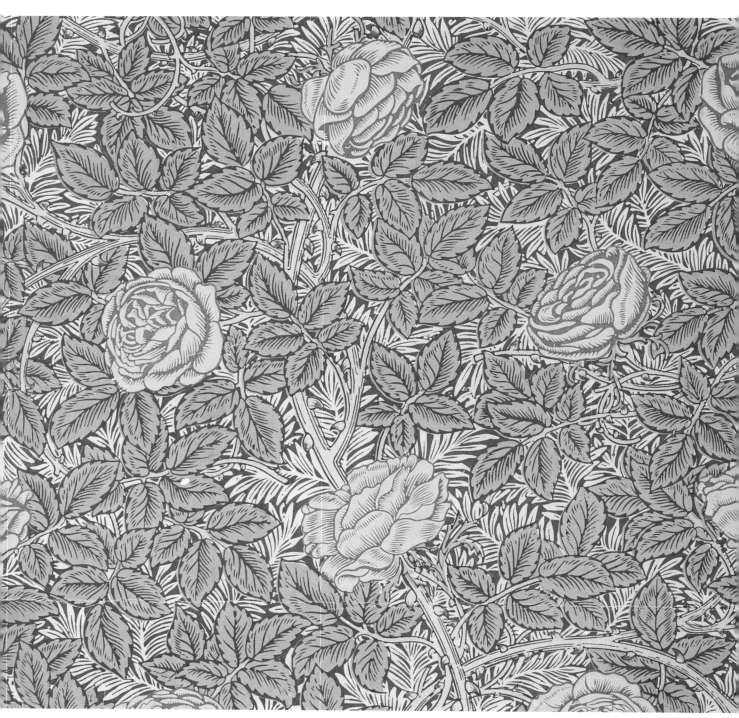

Rose, 1877
Block-printed wallpaper • Private Collection

In his lectures on pattern design, Morris said that when looking at a wall, it was better to be reminded of the close vine trellises that keep the sun out, rather than to count the mediocre floral designs of 'sham' flowers.

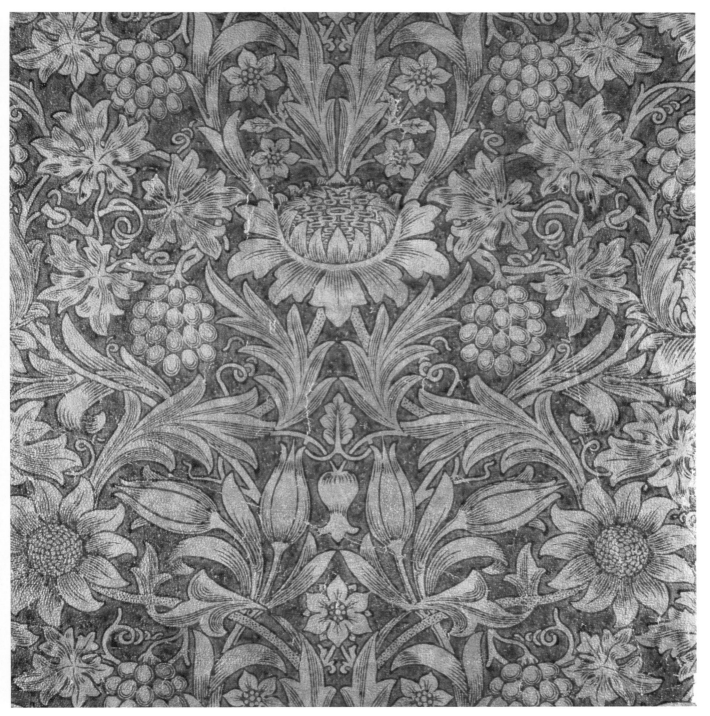

Sunflower, 1879
Block-printed wallpaper • Private Collection/
The Stapleton Collection

Different versions of this design exist, this one being the most luxurious and rich in colour. One version uses white flowers on a pale yellow background, while another uses the same white flowers but on a dark ground.

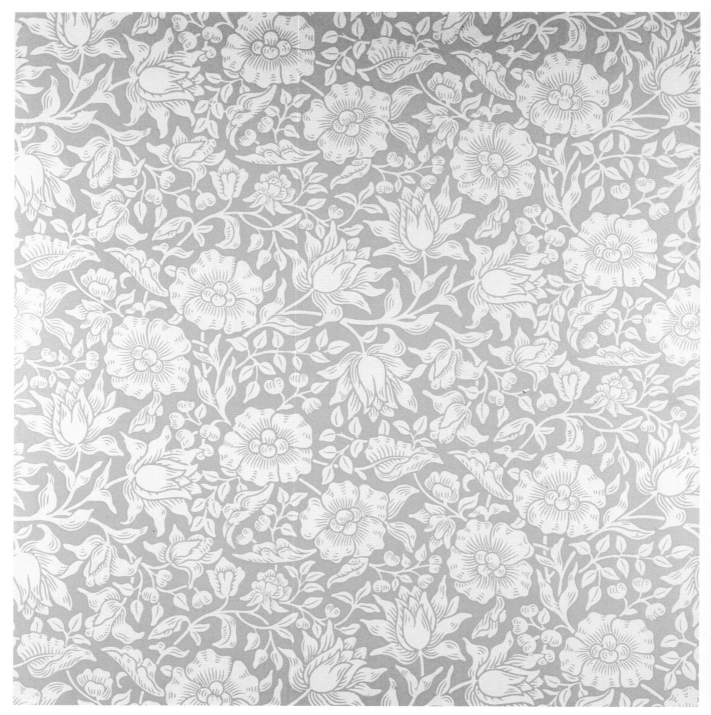

Mallow, 1879, by Kate Faulkner (1841–98)
Block-printed wallpaper • Private Collection

The name of this flower is derived from the Latin *malva*, the origin of the English word
'mauve'. In this stylized version of the flower, no reference is given to colour, only the
shape, to create a pattern.

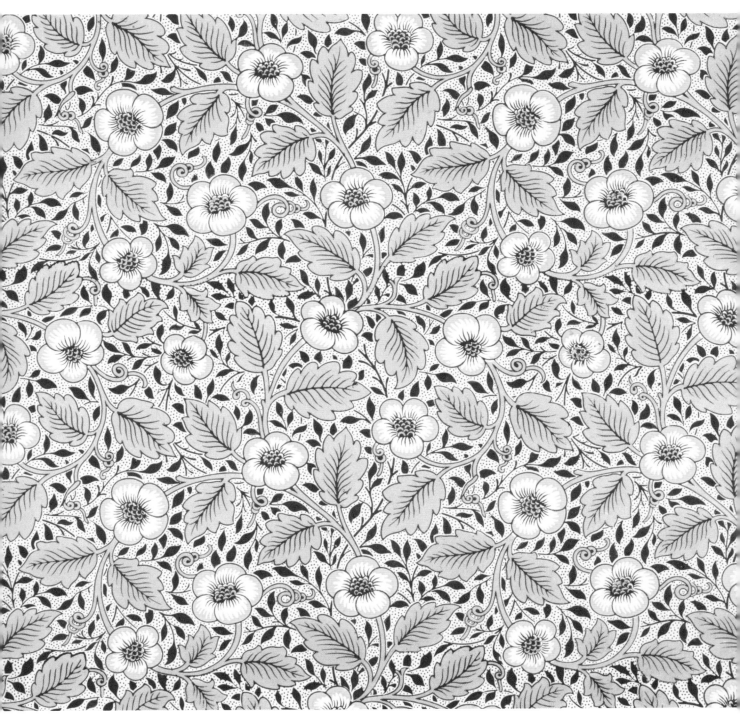

Christchurch [sic], 1882
Block-printed wallpaper • Private Collection/The Stapleton Collection

William Morris and Burne-Jones collaborated on a range of stained glass, fabrics and tiles for Christ Church, designed by George Gilbert Scott, in Southgate, a small village north of London.

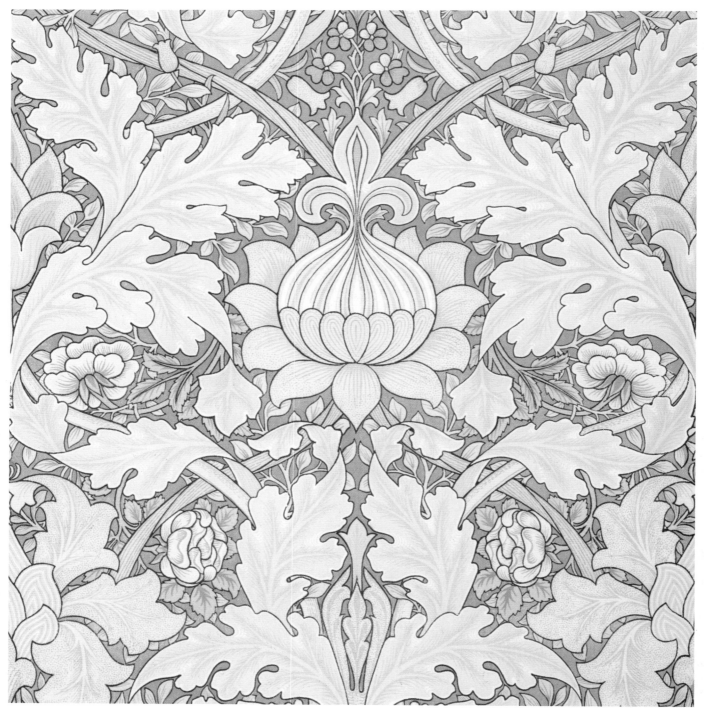

St James's, 1881
Block-printed wallpaper • Calmann and King, London

In the summer of 1880, William Morris attended a meeting to discuss the decoration of some rooms and grand staircase at St James's Palace in London. Queen Victoria approved the design in October of the same year.

St James's, 1881
Block-printed wallpaper • Private Collection

This design is so complex that it requires 68 blocks to print it. The red colourway version shown here is one that became available commercially through the showroom of Morris & Co.

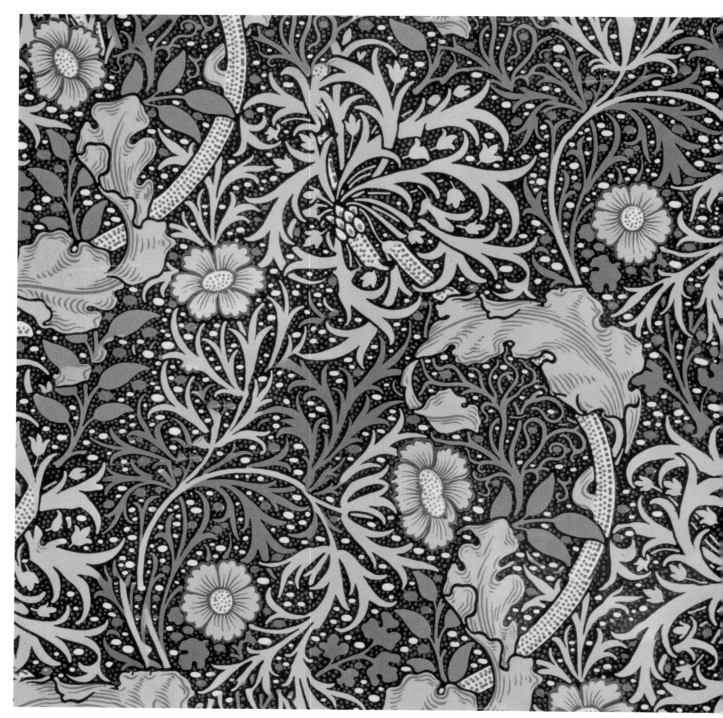

Seaweed, 1890s, probably by John Henry Dearle
Block-printed wallpaper • Private Collection

A gorgeous design infused with and indebted to Morris's style but actually an example of Dearle's mature work. Of course Dearle's collaborations with Morris and indeed his own designs were usually released under the Morris name.

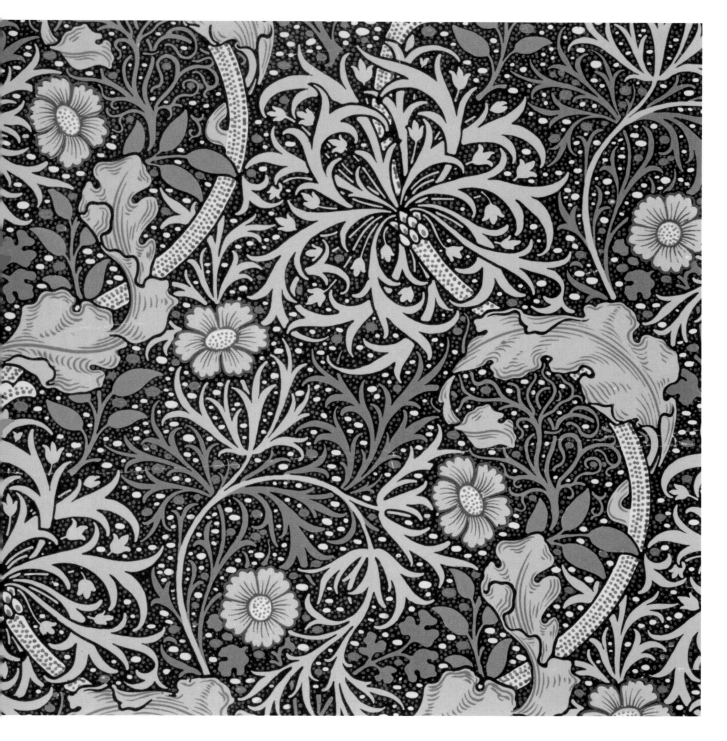

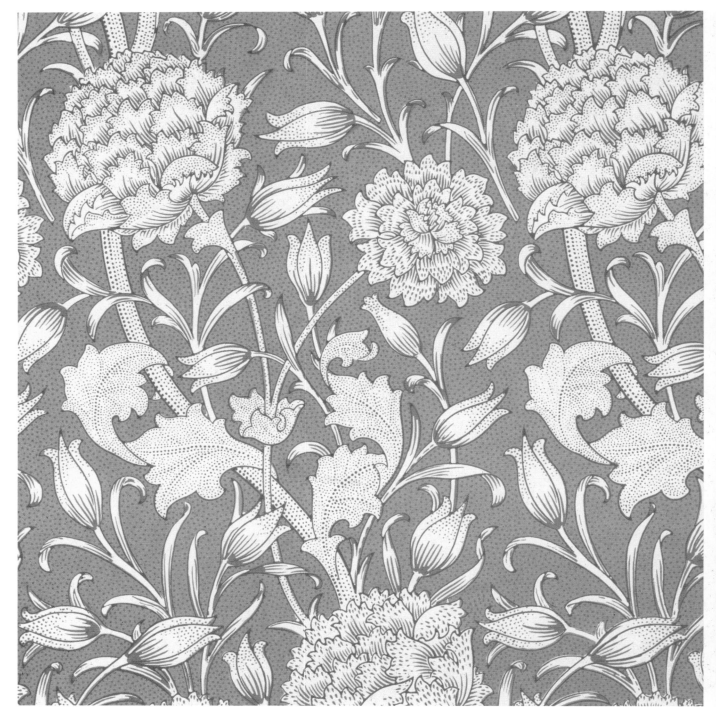

Wild Tulip, 1884
Block-printed wallpaper • Private Collection/The Stapleton Collection

There are several colourways for this wallpaper, which adopts the diagonal meandering motif so typical of Morris's designs. The peonies growing at Kelmscott Manor were probably inspirational to the design.

Garden Tulip, 1885
Block-printed wallpaper • Private Collection

In contrast to many of his earlier complex wallpapers, 'Garden Tulip' is a much simpler and clearer design of stylized coloured tulips that anticipates Art Nouveau in its 'whiplash' motif.

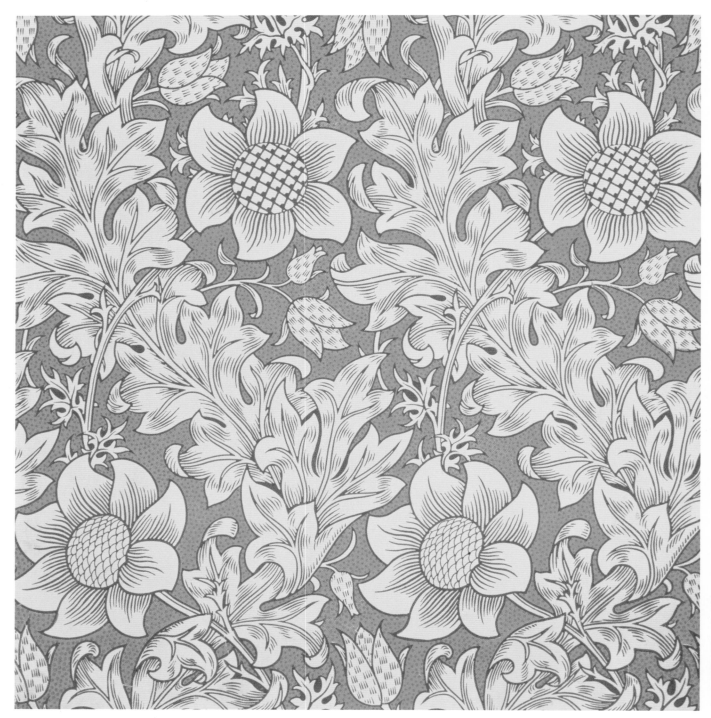

Fritillary, 1885

Block-printed wallpaper • Private Collection/The Stapleton Collection

Morris has chosen the fritillary both as the open flower in the foreground, as the main motif, and as a stylized form, closed and bell-like, in the background, to create this very sinuous design.

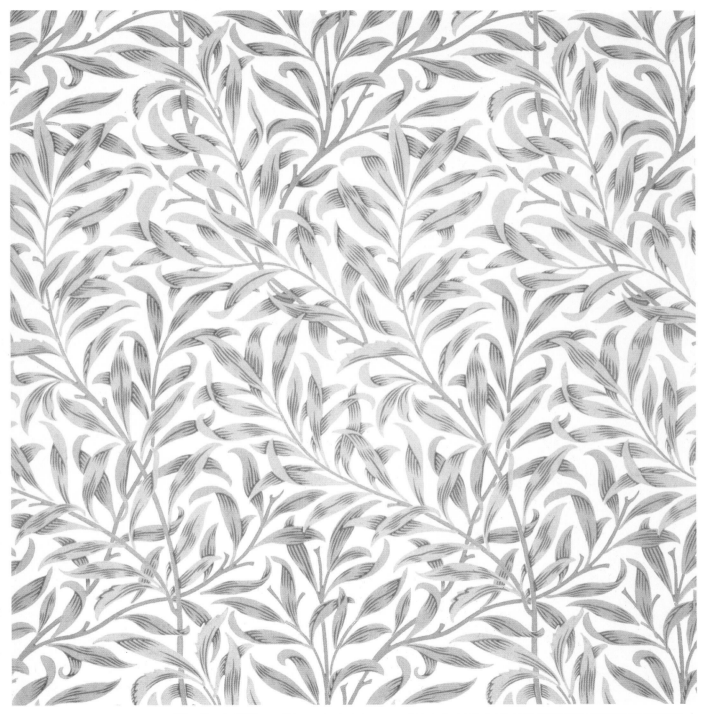

Willow Bough, 1887
Block-printed wallpaper • Private Collection

This very simple design was available in three colourways, and inspired by the many long walks Morris took to study the flora and fauna. He also studied sixteenth-century woodcut drawings of herbs.

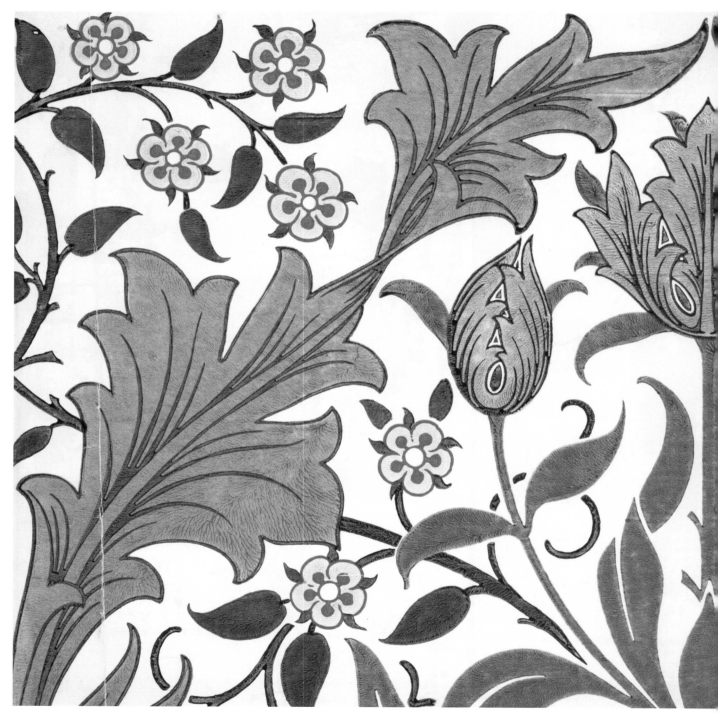

Tulip, late 19th century
Block-printed paper • Private Collection/The Stapleton Collection

This design is for a frieze, as a border below a dado rail. The stylized tulip heads are repeated as a motif in its foliage, the acanthus leaves providing a border to the central design.

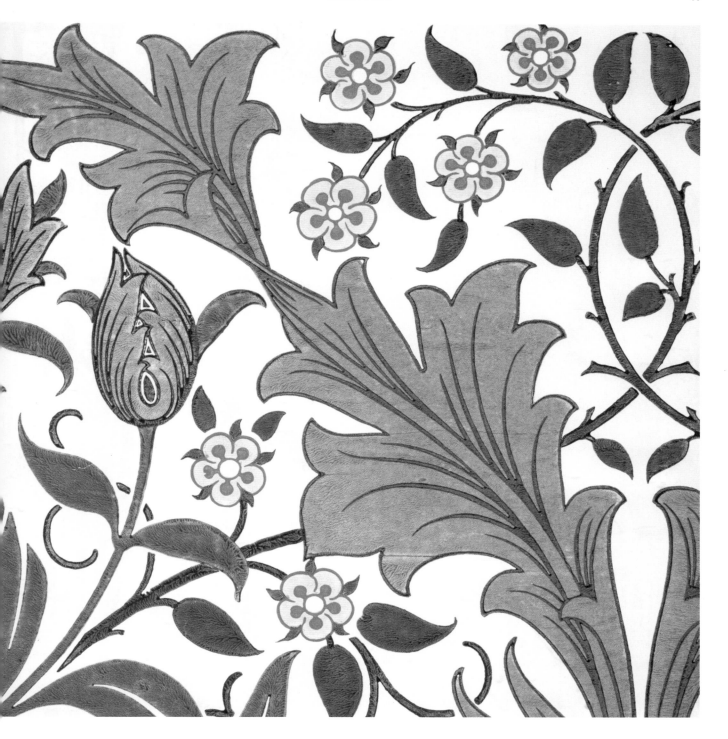

Merton, 1888, by Kate Faulkner
Block-printed wallpaper • Private Collection/The Stapleton Collection

Designed by Kate Faulkner, one of two sisters of Charles Faulkner (1833–92). Both girls worked in Morris's design studio, and unusually for the time, were paid at the same rate as the male staff.

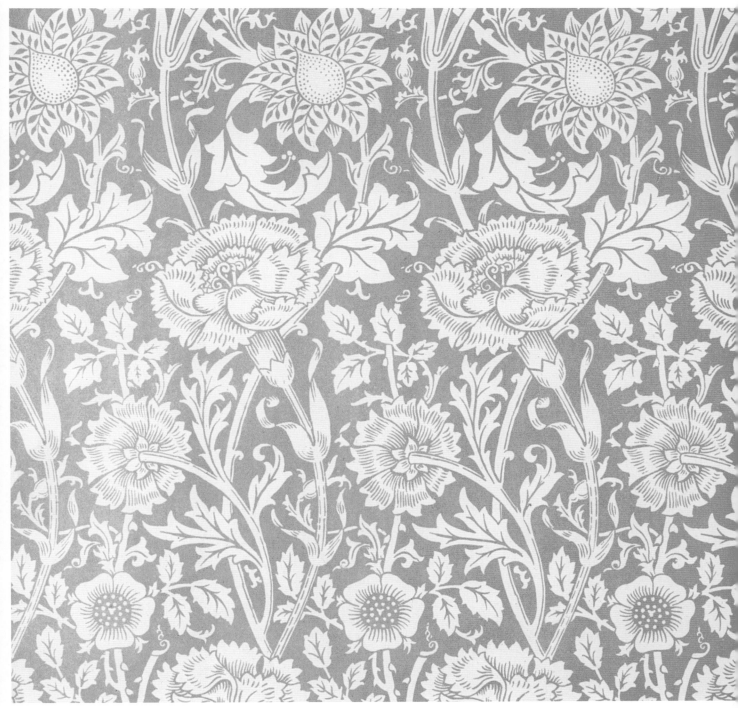

Pink and Rose, 1890
Block-printed wallpaper • Private Collection

Another simple design in which the carnation and rose flowers are in relief to the pink printed background. Both the red rose and red carnation are used as symbols of socialism.

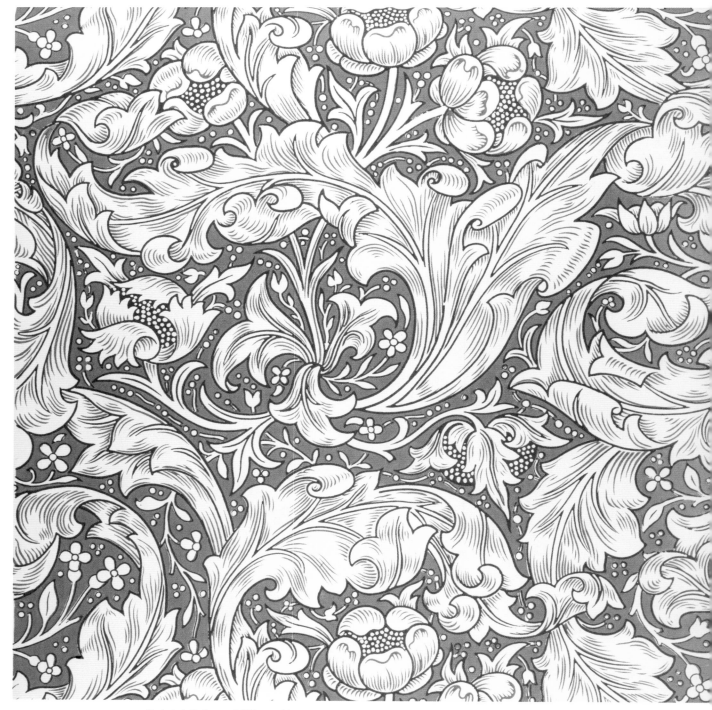

Bachelor's Button, *c.* 1892
Block-printed wallpaper • Private Collection

There are several varieties of the flower bachelor's button, this one being a medicinal herb used to treat migraines. It may well have grown at Kelmscott Manor, its pretty daisy-like flowers with a citrus scent.

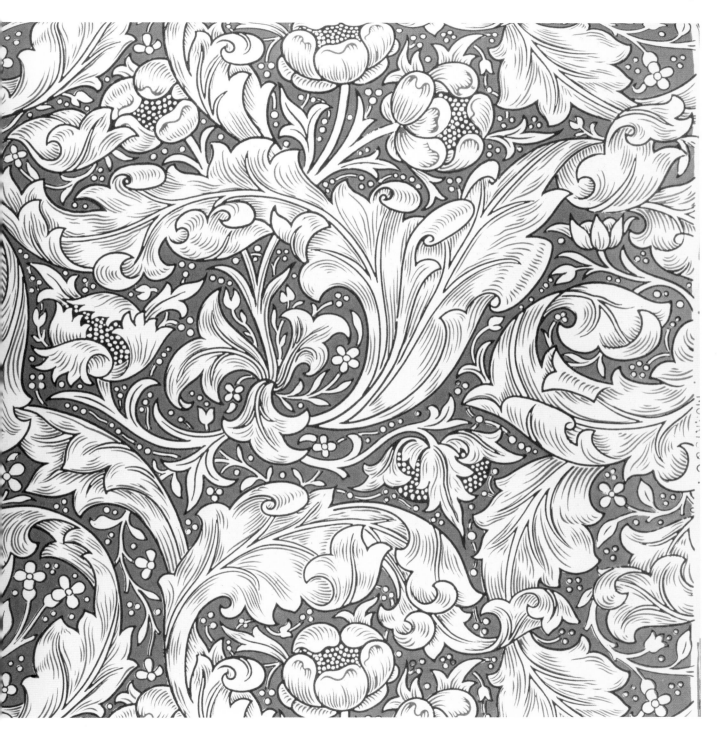

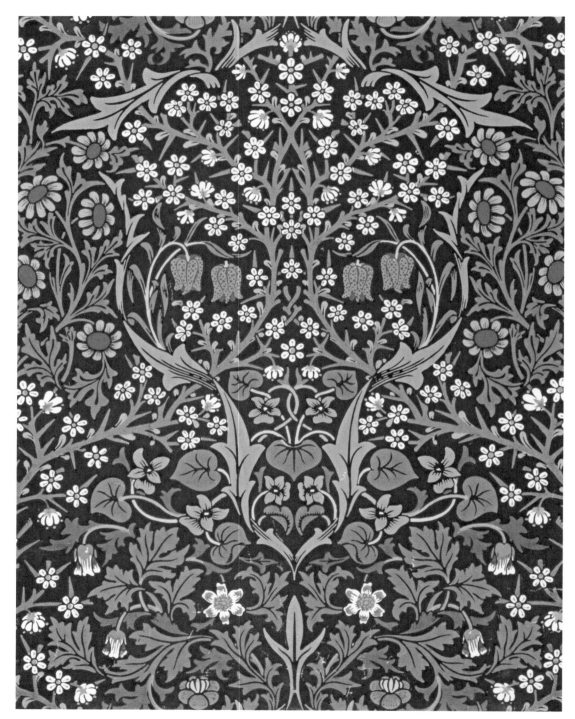

Blackthorn, 1892
Block-printed wallpaper • Private Collection

Although attributed to William Morris, it is believed that John Henry Dearle, who had been designing his own patterns since 1887, may have contributed to the 'Blackthorn' design. It is very elaborate compared to the simpler forms being used by Morris at this time.

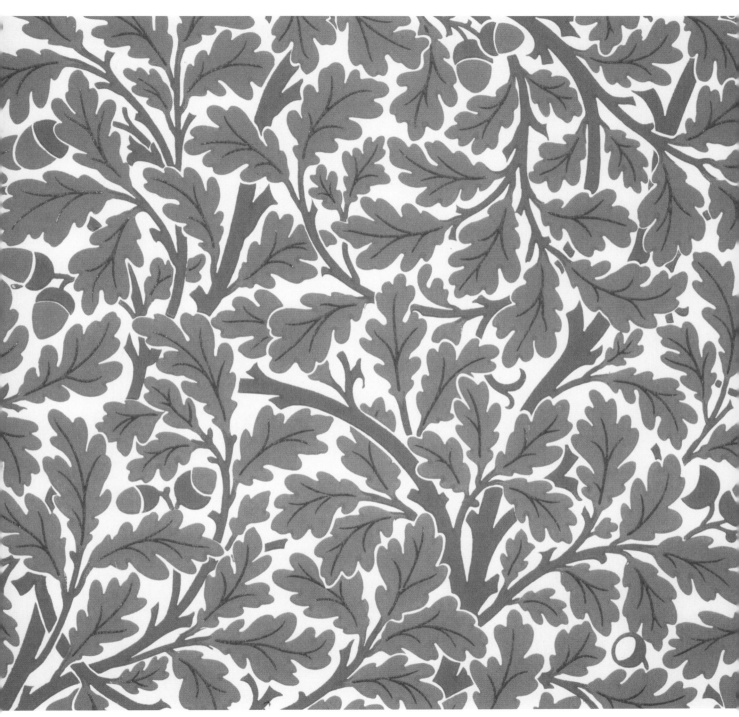

Oak Tree, 1896, by John Henry Dearle (1860–1932)
Machine printed wallpaper • Victoria & Albert Museum, London

One of three different colourway versions, this simple design of oak leaves and acorns was produced by Dearle and printed by Jeffrey & Co., using offset litho printing rather than the slower block method.

Granville, 1896 by John Henry Dearle
Block-printed wallpaper • Private Collection

A densely interwoven and intricate pattern by Dearle, showing the extent of Morris's influence. The small red flowers punctuate the scrolling acanthus leaves of blue and green.

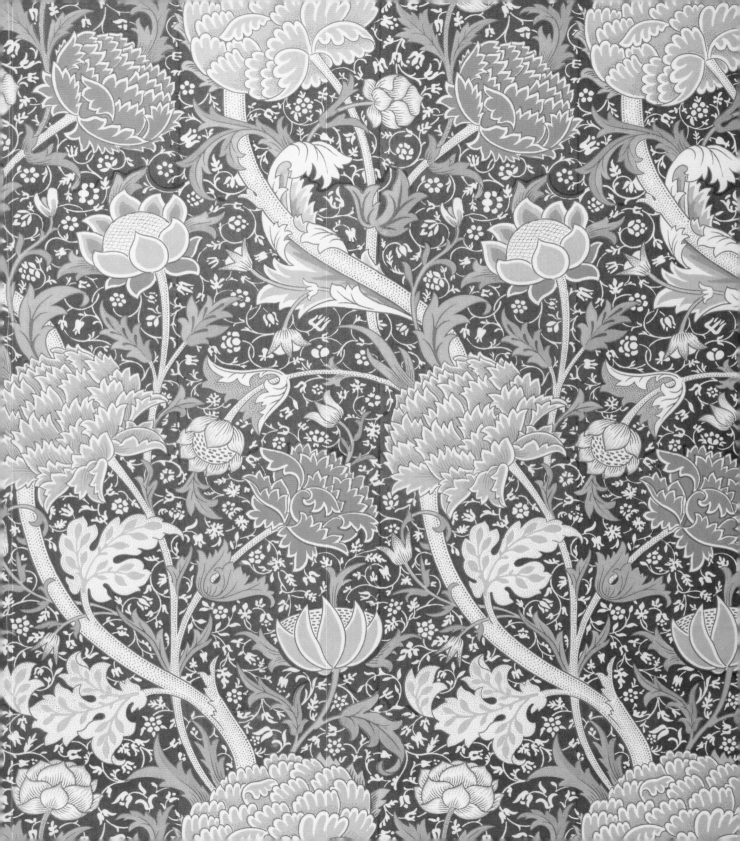

Printed Textiles

Inspired by the success of his wallpaper range, Morris turned his design genius to fabrics to enhance middle-class interiors with materials for upholstery, curtains and soft furnishings.

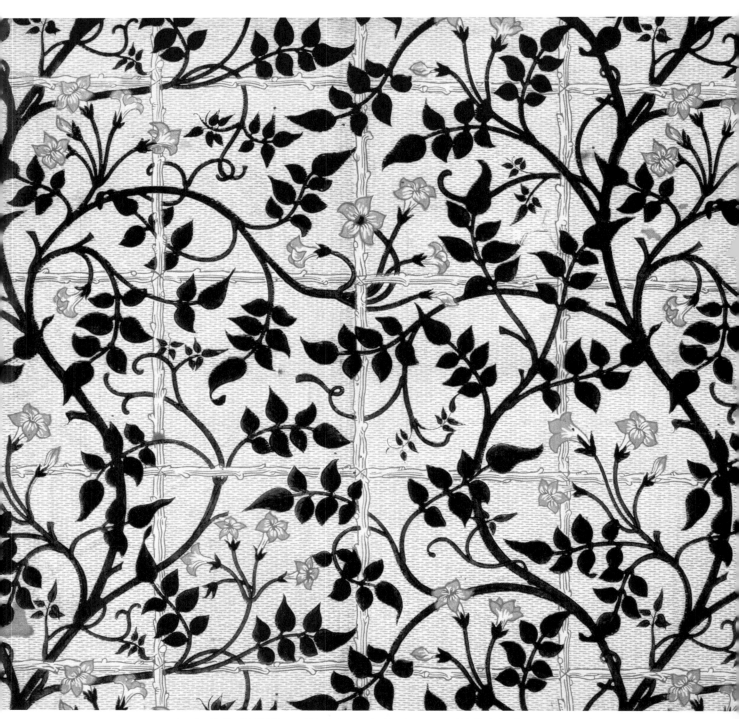

Jasmine Trellis, 1868–70
Block-printed cotton • Private Collection/The Stapleton Collection

This design, inspired by the success of his 'Trellis' wallpaper, is Morris's first in textile. The initial run was printed by Thomas Clarkson, but later transferred to the much-favoured Thomas Wardle.

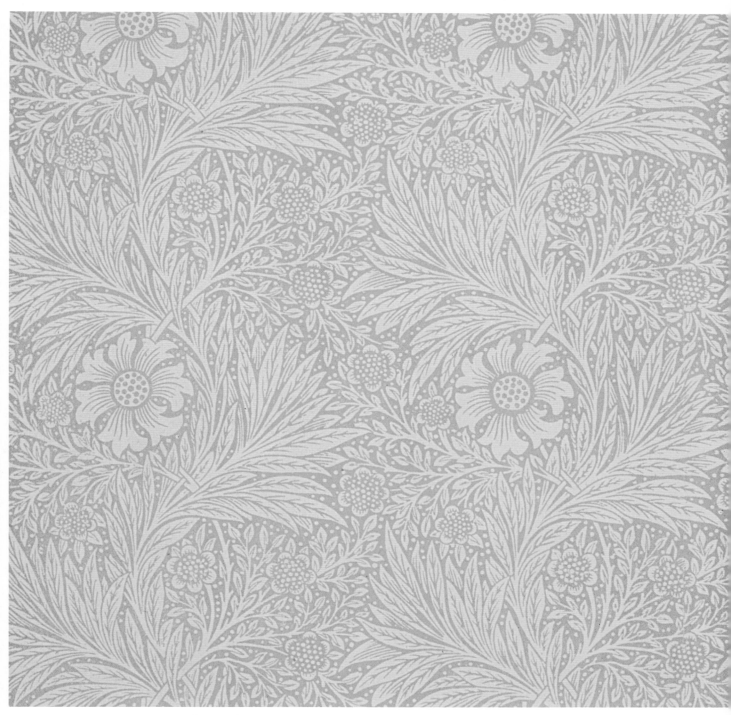

Marigold, 1875
Block-printed silk • Victoria & Albert Museum, London

Printed by Thomas Wardle, the first of many Morris designs executed by him, the fabric was shown at the Paris Exposition Universelle of 1878. Wardle was president of the Silk Association.

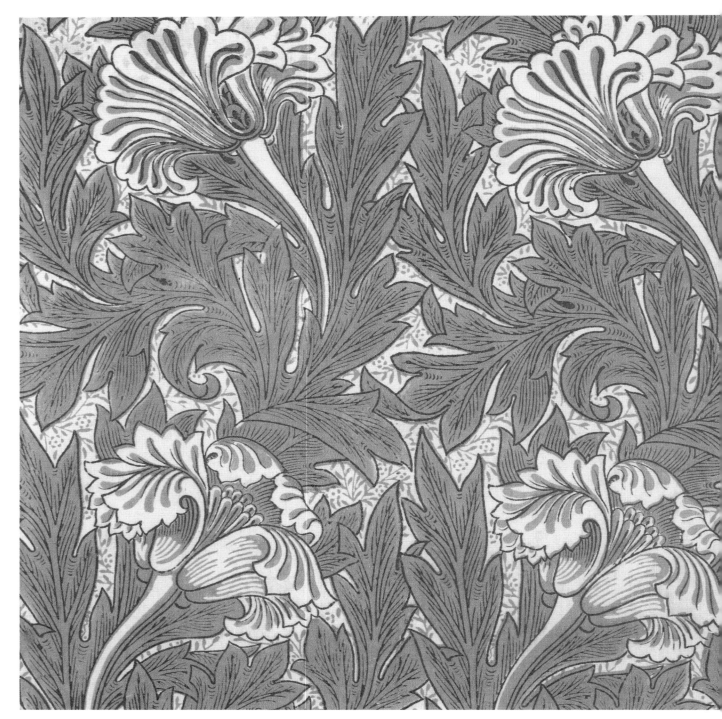

Tulip, 1875
Block-printed cotton • Art Gallery of South Australia, Adelaide

One of three designs registered on the same day, the others being 'Marigold' and 'Larkspur', demonstrating Morris's preoccupation with wallpaper design at this time and the transfer of those ideas into textiles.

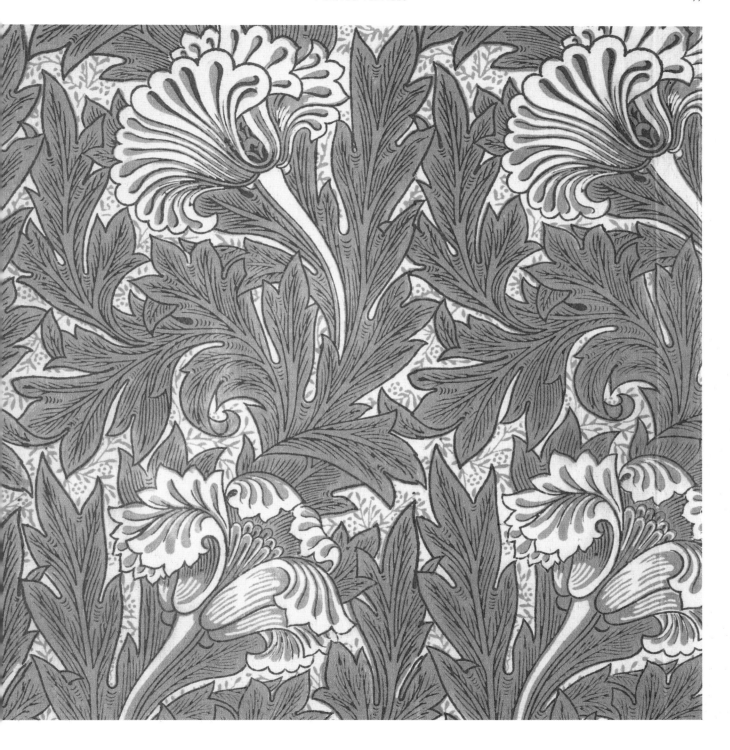

Bluebell or Columbine, 1876
Block-printed cotton • Victoria & Albert Museum, London

The vagueness of the title suggests Morris intended little likeness to the actual flowers as stated. More likely as a mature designer, he appropriated the highly stylized patterned forms of Owen Jones and applied a name in retrospect.

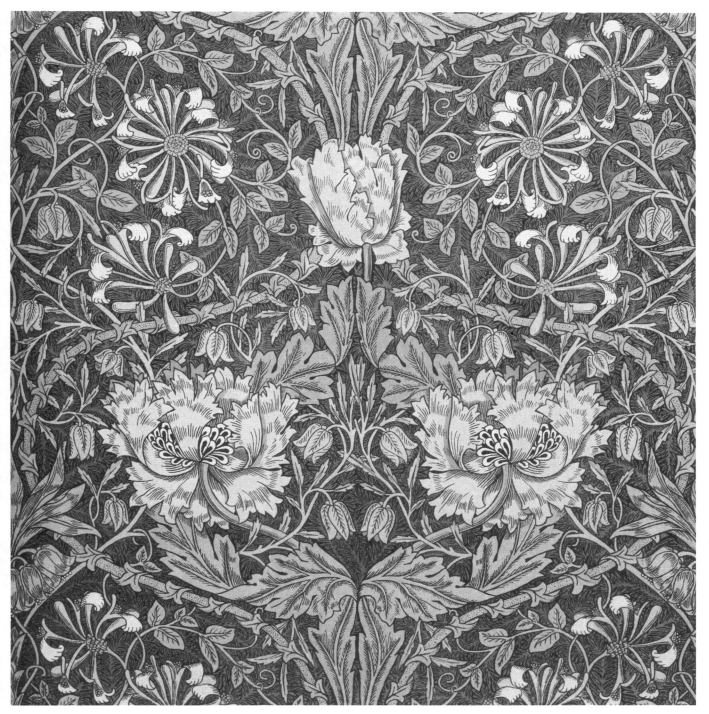

Honeysuckle, 1876
Block-printed cotton • Private Collection

Wardle experimented with this design on both silk and cotton. The former had a translucent quality lacking in the cotton version, which is shown here. Cotton was probably more popular as a furnishing fabric due to price and durability.

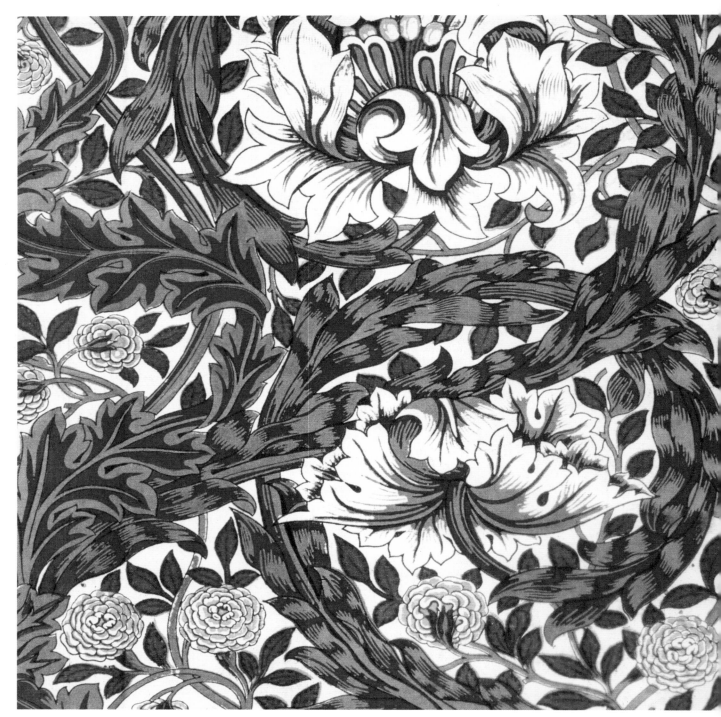

African Marigold, 1876
Block-printed cotton • Private Collection

As a well-read designer, Morris must have been aware of nineteenth-century colour theories. This design demonstrates that understanding by the juxtaposition of two complementary colours, blue and yellow, which emphasizes the strength of colour in each.

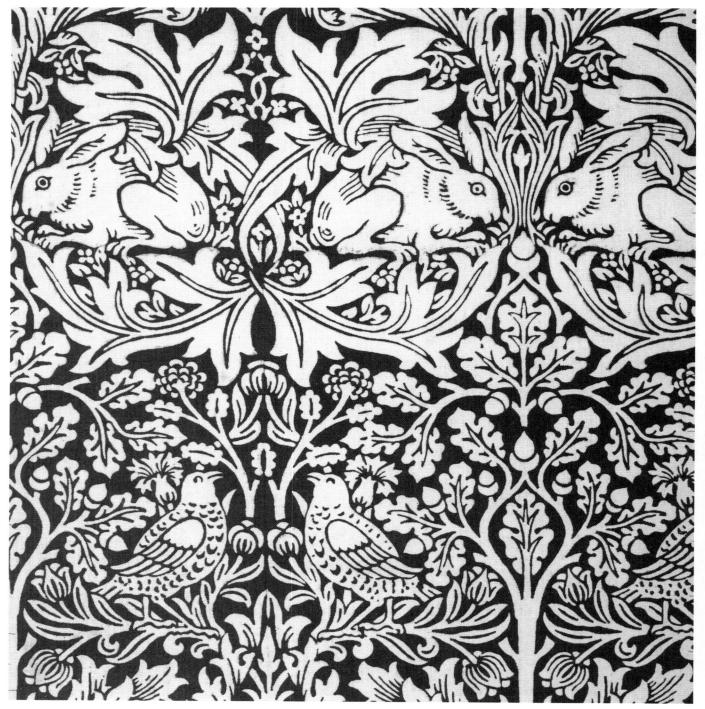

Brother Rabbit, 1880–81
Block-printed cotton • Private Collection

A highly detailed design of foliage including oak leaves and acorns, together with birds and rabbits, all of which were familiar in the English countryside. This was the last pattern to be printed by Wardle at Leek.

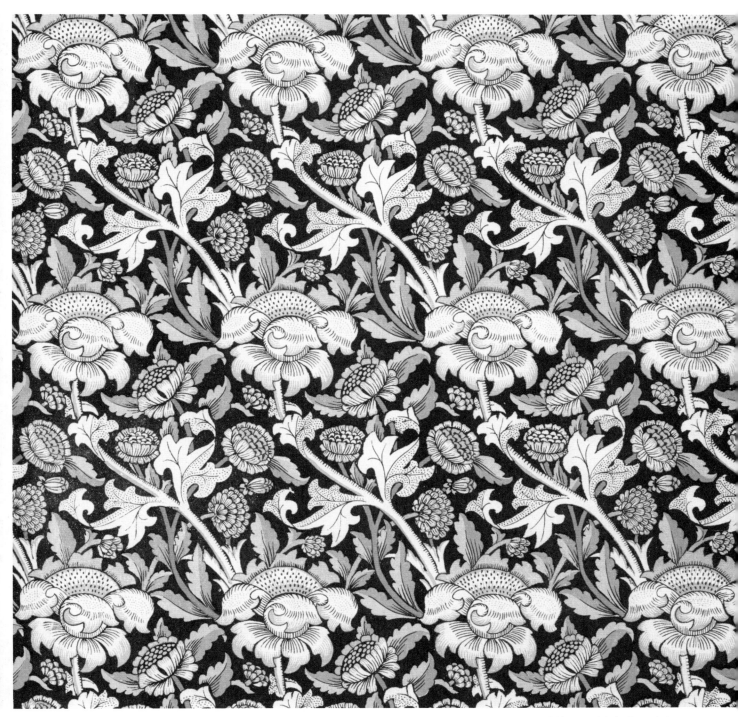

Wey, 1883
Block-printed cotton • Private Collection

A design that utilized the indigo discharge method but was also available as a printed cotton velveteen, which was very popular in the 1870s. Cotton velveteen was available as an alternative on several other patterns too.

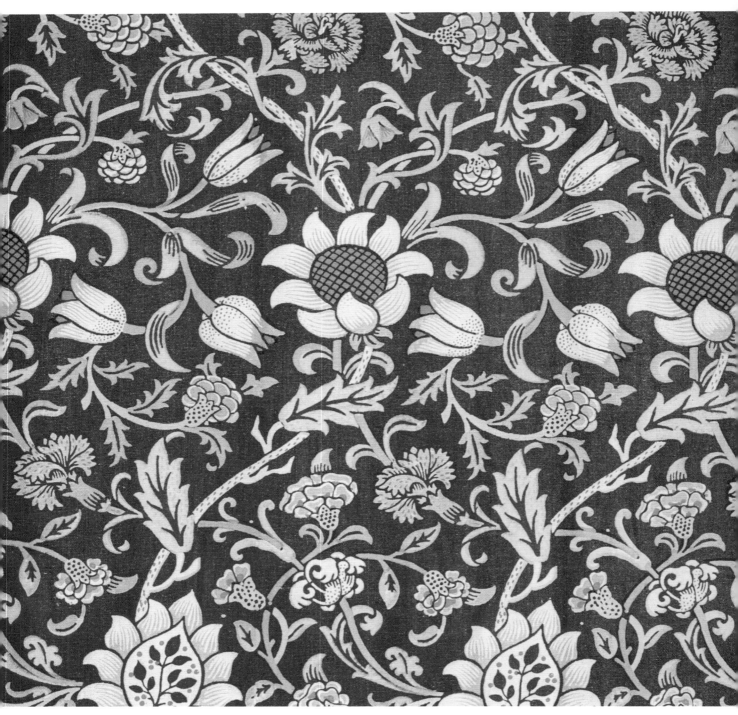

Evenlode, 1883
Block-printed cotton • Private Collection

The River Evenlode is a tributary of the River Thames and flows through Oxford close to Kelmscott Manor. Much of the river is on private land and is renowned for its fishing and unspoilt natural flora.

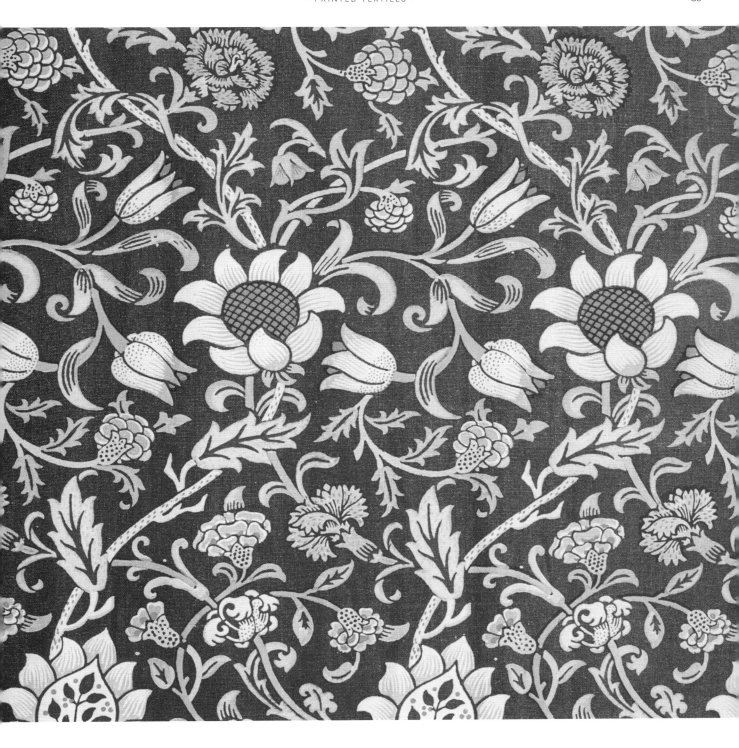

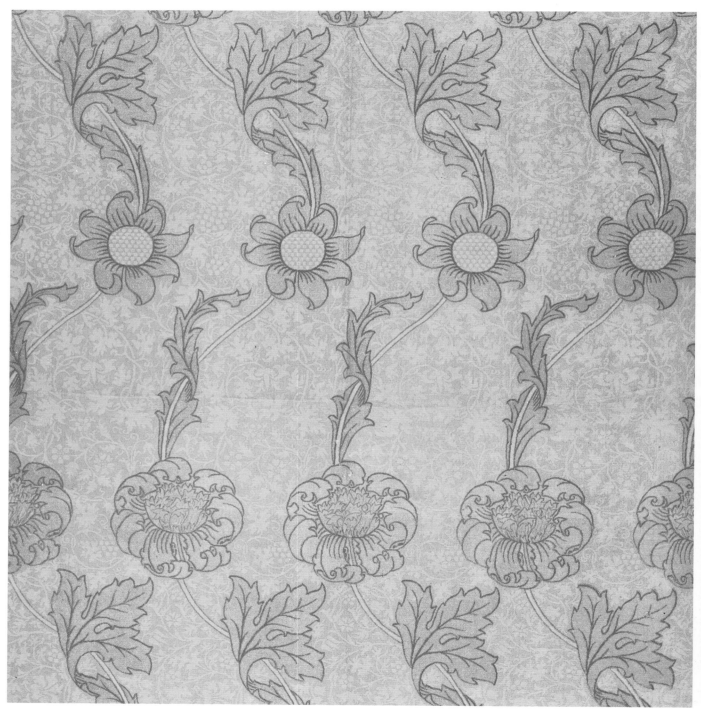

Kennet, 1883
Block-printed cotton • Private Collection

Unusually, the 'Kennet' design was available as both a printed and woven fabric in 1883, both of which were manufactured at Merton Abbey. The River Kennet was well known to Morris as it flows through Marlborough, where he attended school.

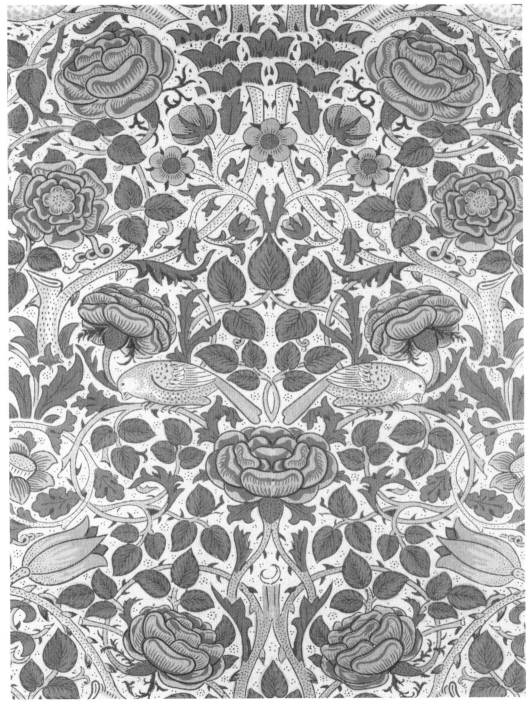

Rose, 1883
Block-printed cotton • Private Collection

Despite the almost white background, Morris insisted on using the indigo discharge method, which entailed extensive bleaching. The design is one of only three fabrics that incorporated birds as well as flowers.

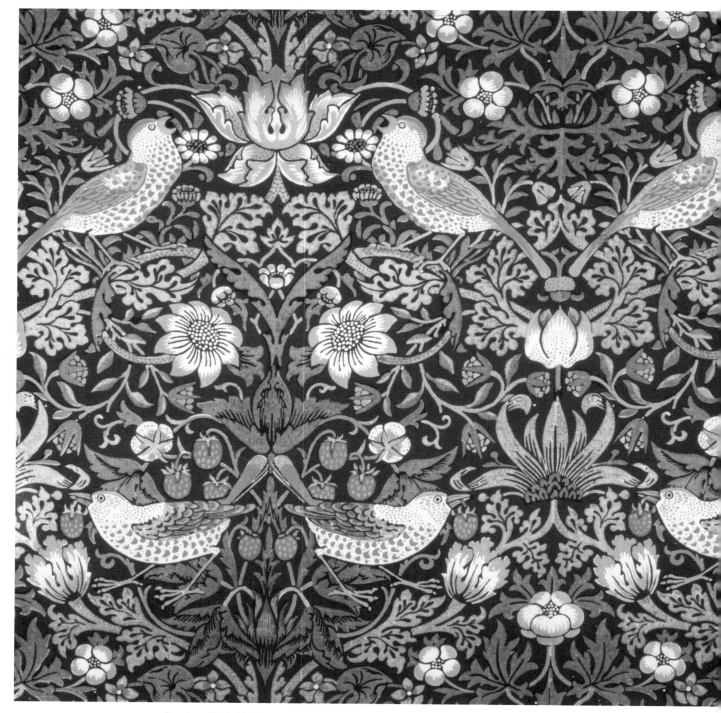

Strawberry Thief, 1883
Block-printed cotton • Private Collection/The Stapleton Collection

Using the indigo discharge method for the background, Morris then supervised the overprinting of the yellow and red elements, which caused him a lot of anxiety. It nevertheless proved to be one of his most successful fabrics.

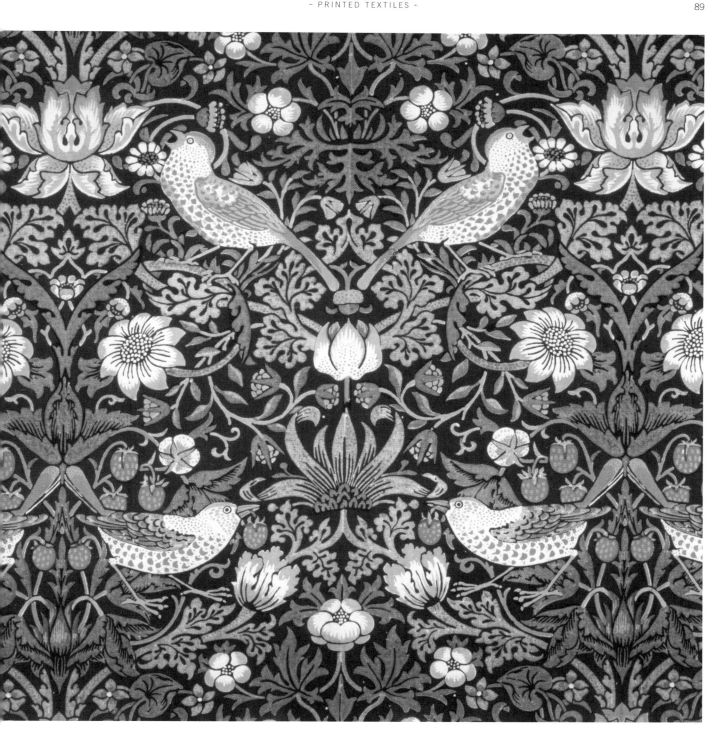

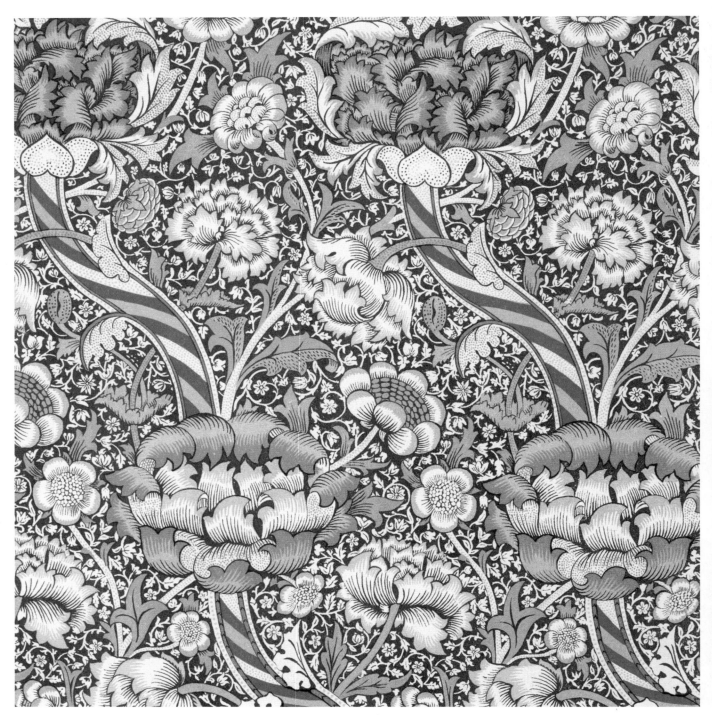

Wandle, 1884
Block-printed cotton • Calmann and King, London

More a stream than a river, the Wandle ran close to the Merton Abbey premises and provided clean water for the dyeing process. It therefore seems appropriate that Morris should elevate its status and name a fabric in his river series after it.

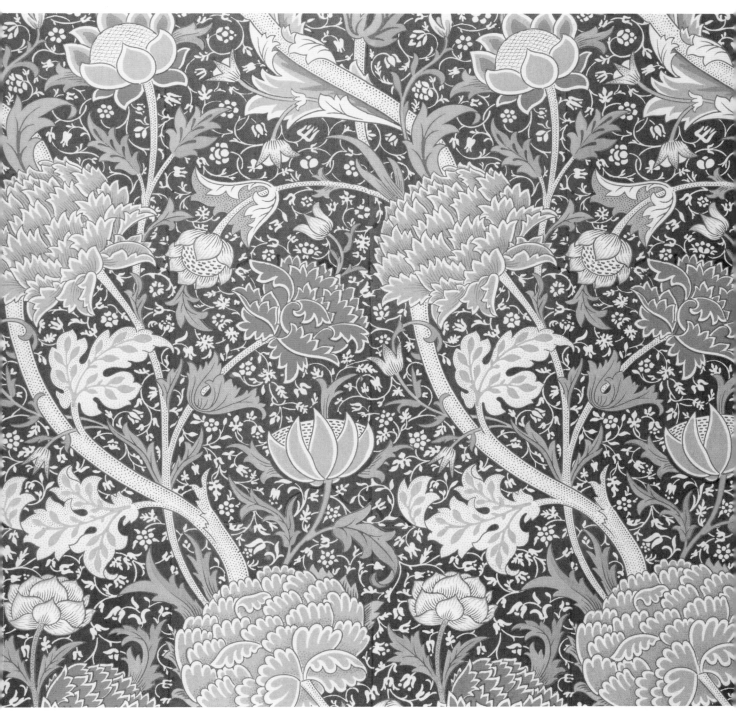

Cray, 1884
Block-printed cotton • Private Collection

This was the grandest and most expensive of Morris's printed fabric designs, as he turned his attention to weaving. It continued to be manufactured well into the twentieth century, but with a lighter coloured ground as fashions changed.

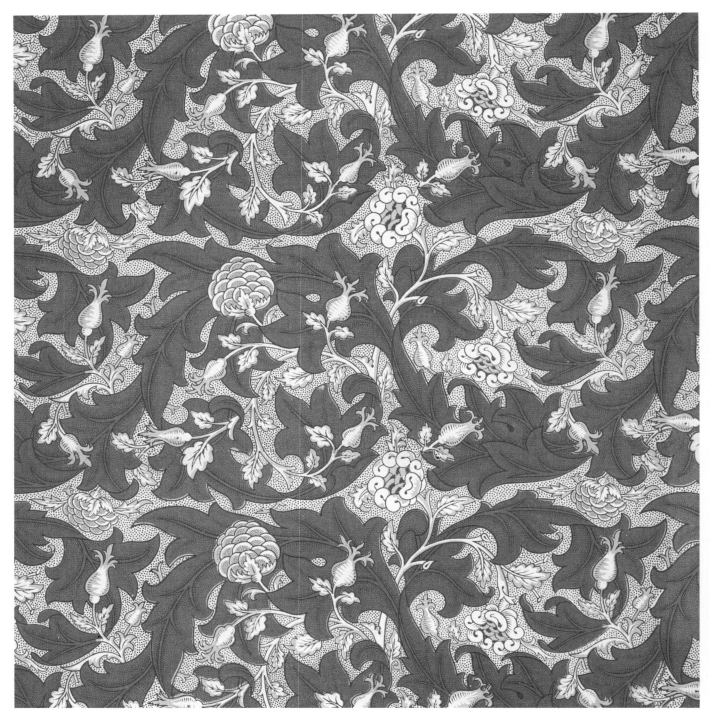

Lea, 1885
Block-printed cotton • Private Collection

'Lea' is one of several designs that were named after English rivers. Unlike most of the other 'river' patterns, this one does not have a sinuous design, suggesting that it was another aspect of this historical river that influenced Morris.

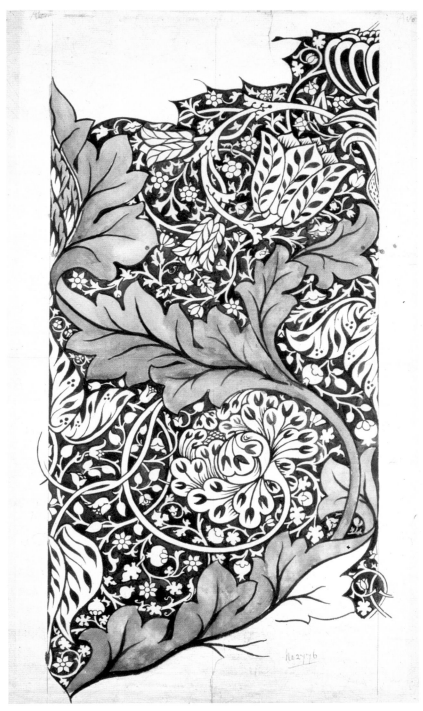

Design for Avon Chintz, 1887, possibly by John Henry Dearle
Pencil and watercolour on paper • William Morris Gallery,
Walthamstow, London

Dearle, rather than Morris, may well have designed 'Avon'. Although named after an English river and with sinuous lines, its influence is probably Indian, hence the reference to chintz.

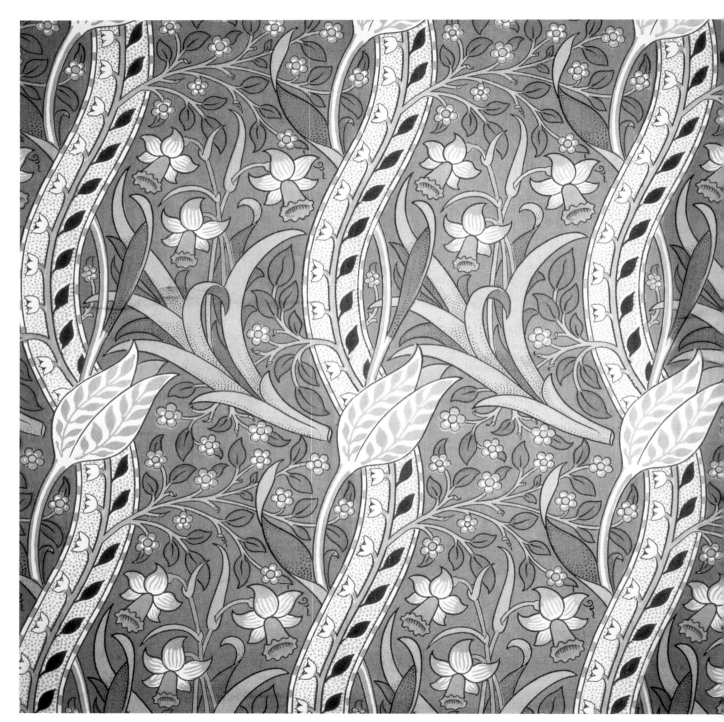

Daffodil Chintz, 1891, by John Henry Dearle
Block-printed cotton • Private Collection

By 1890, Morris had stopped producing repeat pattern designs, and in the following year, Dearle became the chief designer for the Firm. Although one can see Morris's influence in this design, Dearle was beginning to use other sources too.

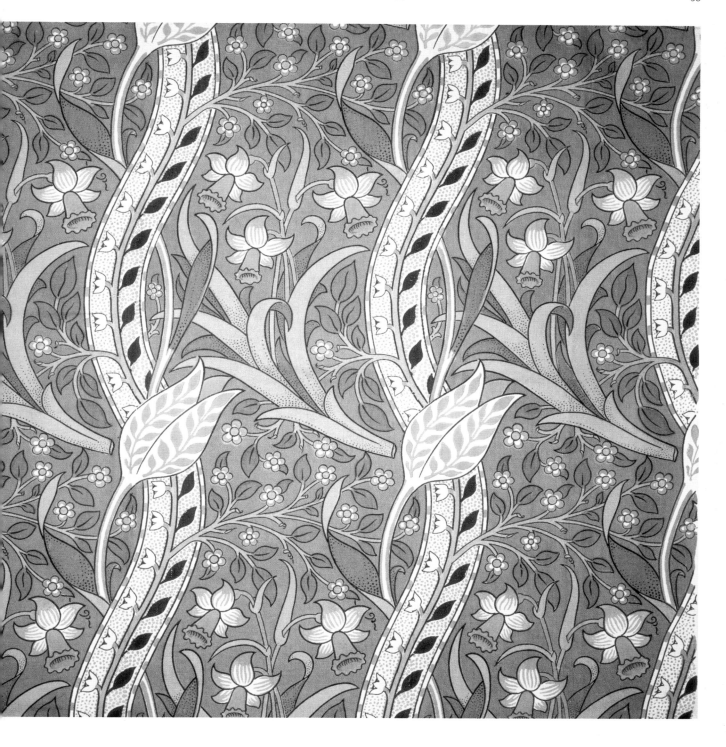

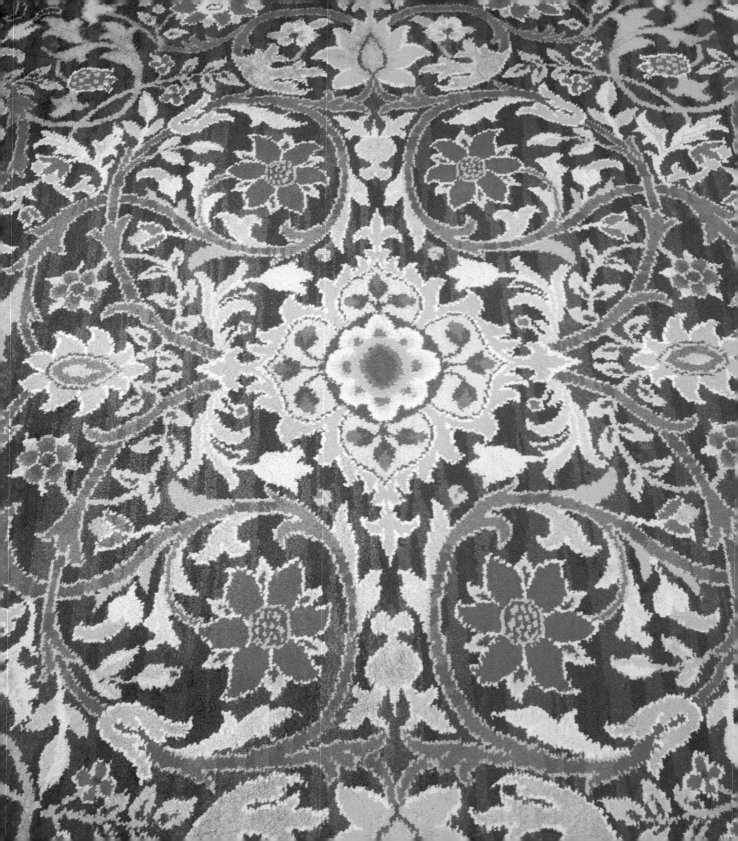

Woven &
Embroidered
Textiles

While Morris regarded tapestry as
the 'noblest' of the weaving arts,
he also applied himself to the mass
manufacture of woven fabrics,
which were produced alongside the
printed designs at Merton Abbey.

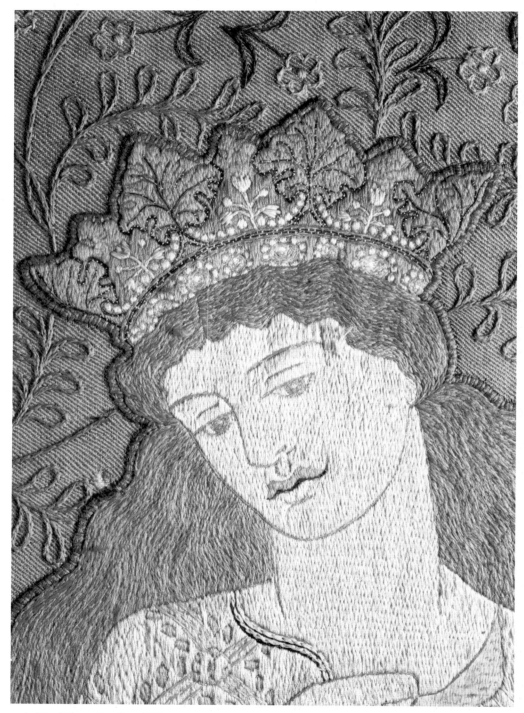

The Legend of Good Women (detail), *c.* **1875**
Tapestry • Private Collection

The design shows the literary influence of Chaucer on Morris's aesthetic, this a story about 10 virtuous women related as a dream vision in poetic form, the first example of the use of the iambic pentameter in English.

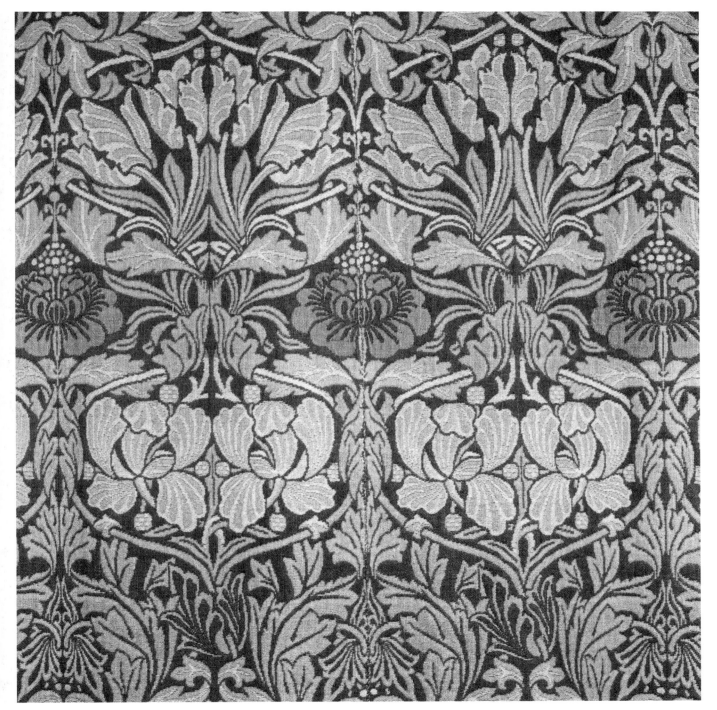

Tulip and Rose, 1876
Woven wool with silk • The National Trust

Woven by the Heckmondwike Manufacturing Co. in Yorkshire, this is the first dateable design by Morris for a woven fabric. The design is meant to be seen in folds rather than flat, with curtaining in mind.

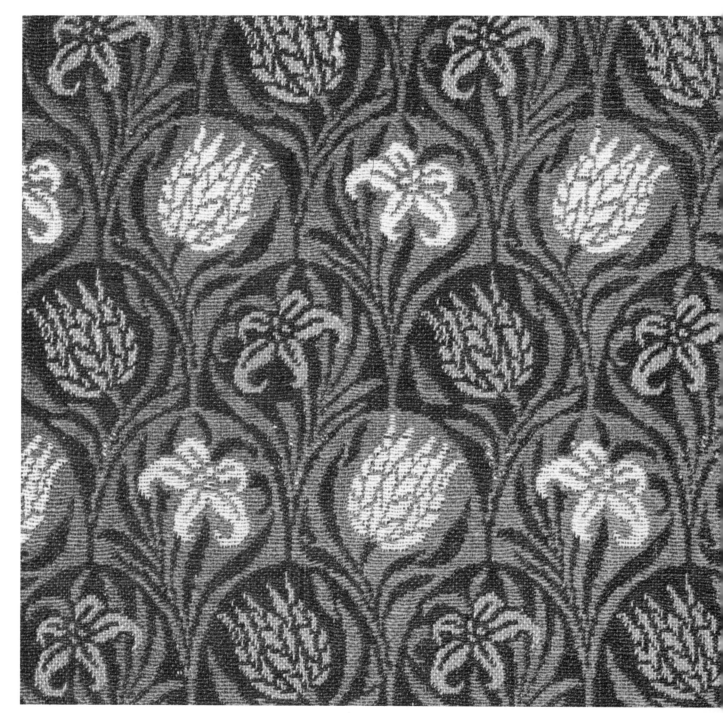

Tulip and Lily, 1875
Woven wool • Private Collection

The early samples of this carpet produced by Heckmondwike Manufacturing Co. were disappointing to Morris, who disliked their colour rendition, so subsequent weavings used wool supplied by Wardle. Morris was also required to provide the drawing transfers for each weave.

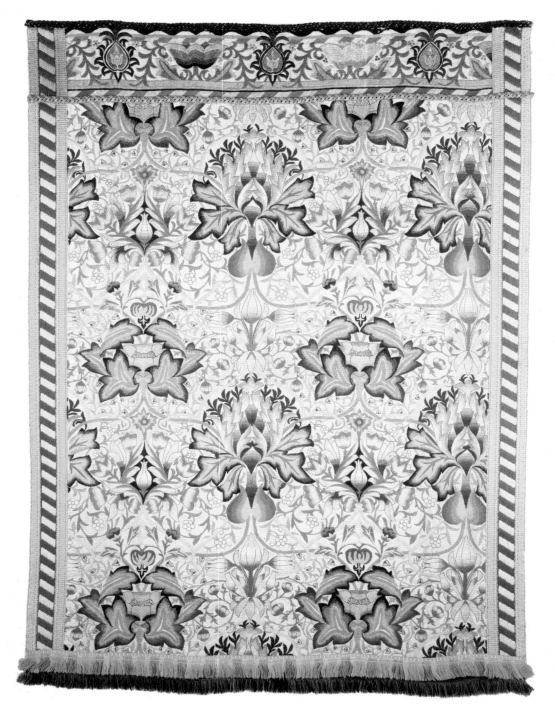

Artichoke, 1877
Woollen embroidery on linen, 207.5 x 153 cm (81⅔ x 60¼ in)
• Victoria & Albert Museum, London

Morris studied many of the Eastern and Indian embroideries at the South Kensington Museum, prior to this undertaking. Mrs Ada Godman, the daughter of one of Morris's clients, Margaret Bell, took nearly 23 years to complete the set of embroideries of which this was one.

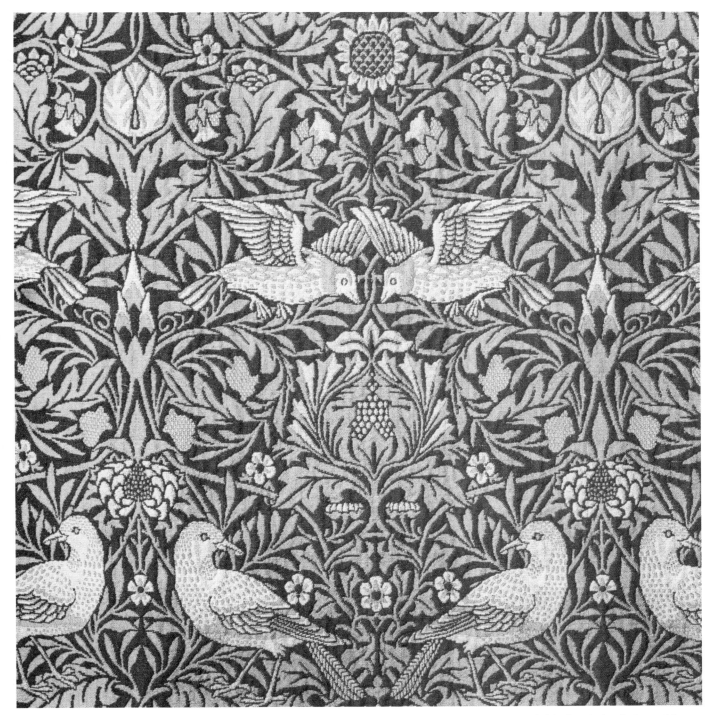

Bird, 1877
Woven wool • Private Collection/John Bethell

This design was executed by Morris while at Queen Square and originally worked on the looms at the same address before production was transferred to Merton Abbey. It was used extensively as a wall hanging at Kelmscott Manor.

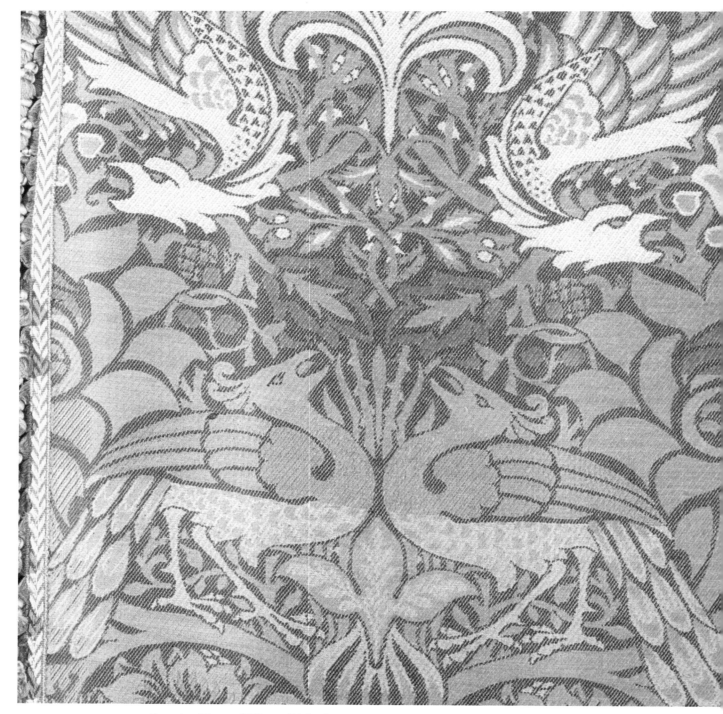

Peacock and Dragon, 1878
Hand woven woollen twill panel, 264.5 x 241.5 cm (104 x 95 in)
• Private Collection/The Fine Art Society and Francesca Galloway

This hand-woven pattern was used at several large homes in decorative schemes, proving particularly popular with overseas clients. The peacock was a popular motif used in decorative schemes at this time.

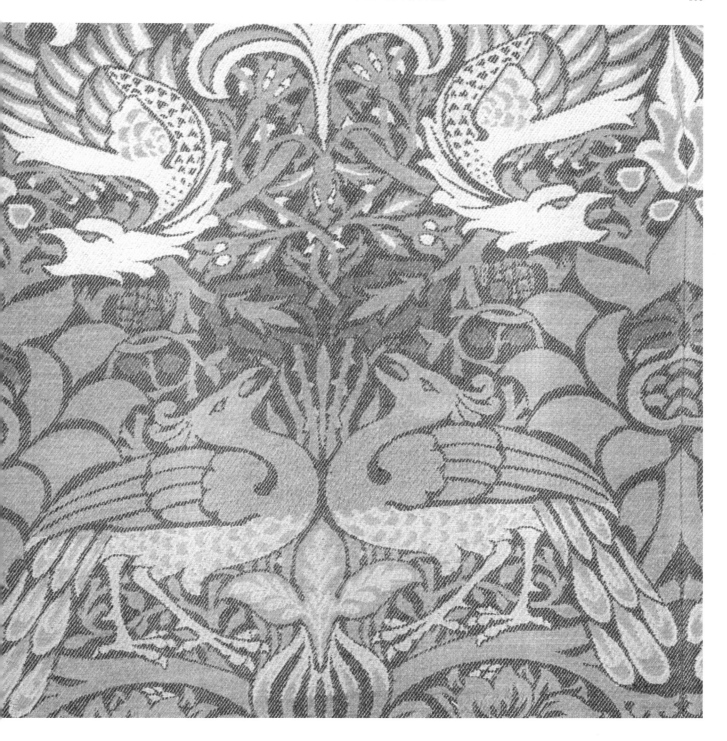

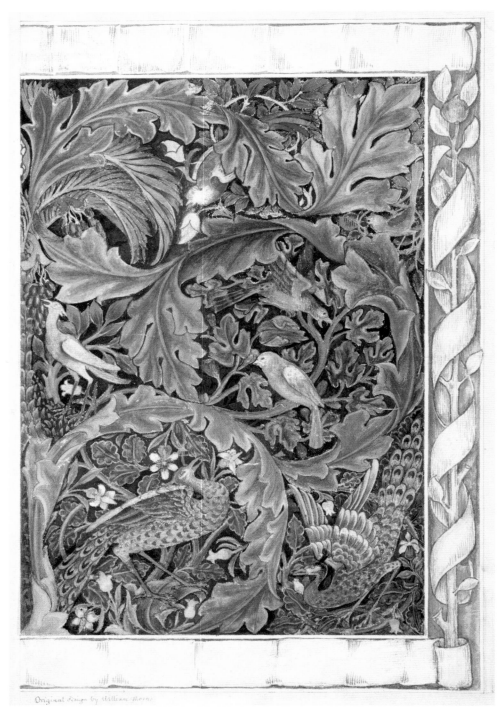

Original design by William Morris

Design for a tapestry with peacocks, 1879–81
Pencil, pen and ink, watercolour and bodycolour on paper,
56.1 x 38.7 cm (22 x 15¼ in) • Victoria & Albert Museum, London

The inspiration for this work may well have come from the decorative scheme known as The Peacock Room, executed by James McNeill Whistler (1834–1903), at the London home of the wealthy art collector Frederick Leyland (1832–92).

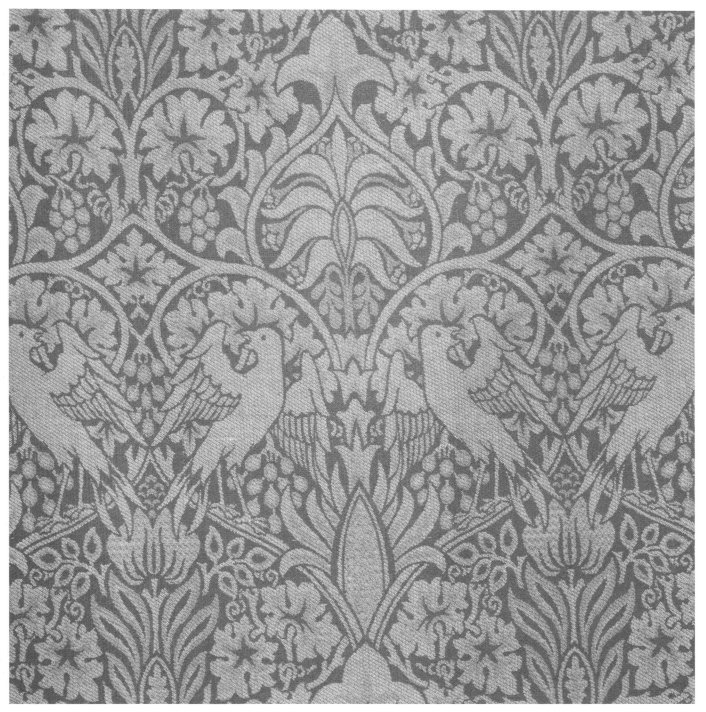

Bird and Vine, 1879
Woven wool • The National Trust

Although intended as a secular piece, the design proved very popular with church commissions due to the Christian Gospel symbols of the dove-like bird and the vine grapes, evoking wine as used in the Eucharist.

Acanthus and Vine (a.k.a. Cabbage and Vine; detail), 1879
Woven wool and silk on a cotton warp, *c.* 181 x 136 cm (71¼ x 53½ in) •
Kelmscott Manor

Morris set up his tapestry loom at Kelmscott House in 1879, and this design became the first tapestry he worked on. He began in May and it was finished in September, taking him 500 hours to complete.

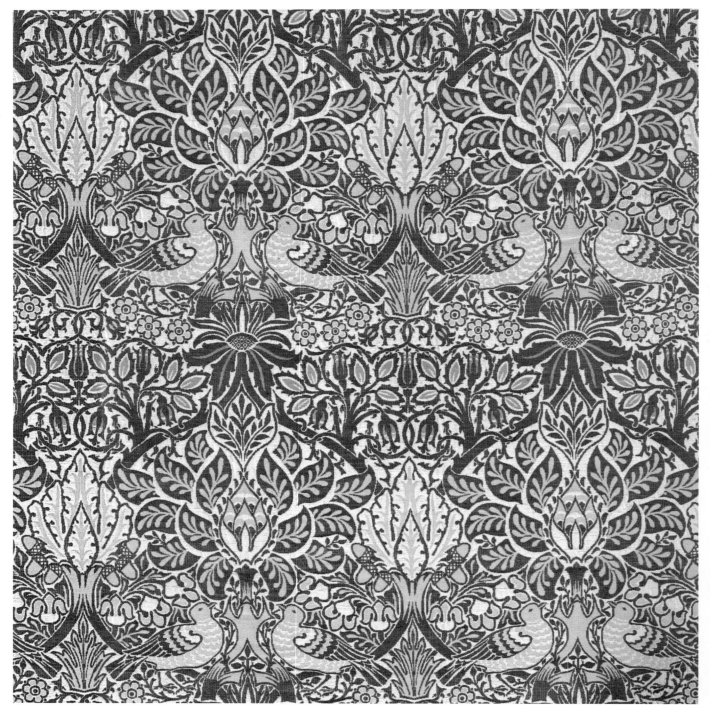

Dove and Rose, 1879
Wool and silk • Art Gallery of South Australia, Adelaide

This broad design was only suited to hangings and curtains, and originally woven at the factory of Alexander Morton and Co., a leading weaver of textiles and lace in Scotland, before being transferred to Merton Abbey. It was available in a number of colourings.

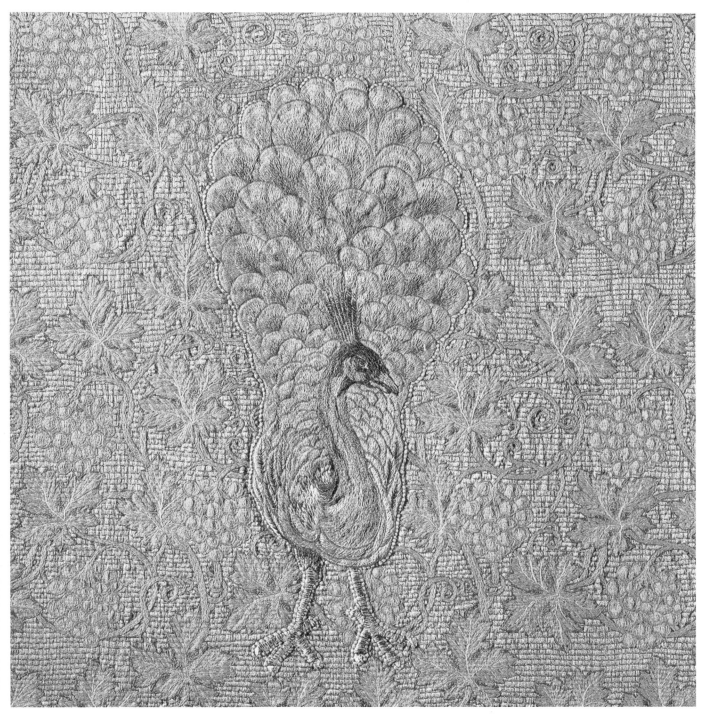

Peacock and Vine, *c.* 1880–1900
Wool on linen • Private Collection/The Fine Art Society, London

This intricate and subtle design depicts vine leaves and bunches of grapes in the background, with an elegant peacock as its decorative motif – probably designed by Philip Webb, 1831–1915. It resembles a secular version of an altar frontal.

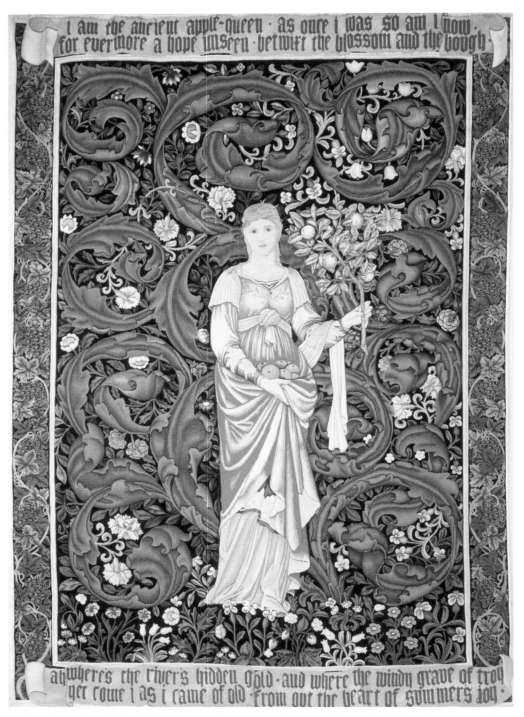

I am the ancient apple-queen · as once i was so am i now · for evermore a hope unseen · betwixt the blossom and the bough

& where's the river's hidden gold · and where the windy grave of troy · yet come i as i came of old · from out the heart of summer's joy ·

Pomona, 1885, by Edward Burne-Jones (1833–1898)
Woven wool and silk on a cotton warp, 320 x 225 cm (126 x 88½ in)
• Whitworth Art Gallery, Manchester

Burne-Jones executed the design of 'Pomona' in 1882 and Morris provided the background detail before 1885, when the tapestry was first woven at Merton Abbey. This was the first of several versions, although later ones were on a smaller scale.

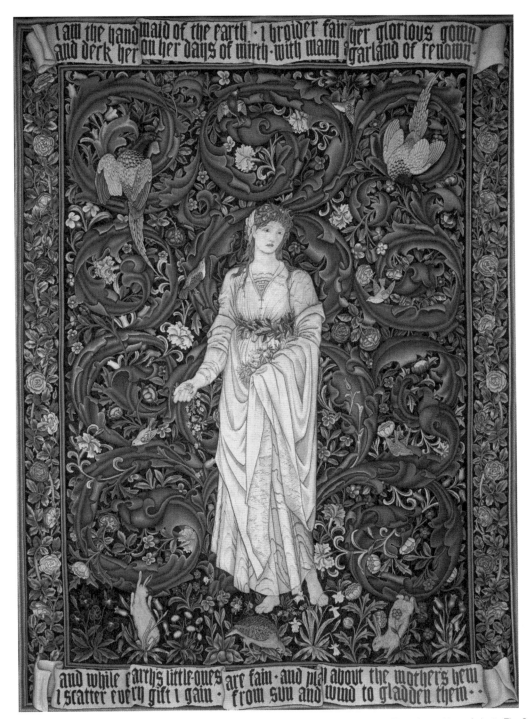

I am the handmaid of the earth · I broider fair her glorious gown
and deck her ou her days of mirth · with many a garland of renown.

and while earths little-ones are fain · and play about the mother's hem
I scatter every gift I gain · from sun and wind to gladden them·

Flora, 1885, by Edward Burne-Jones
Woven wool and silk on a cotton warp, 310 x 222 cm (122 x 87⅜ in)
• Whitworth Art Gallery, Manchester

This tapestry, made to partner 'Pomona', depicts Flora, the goddess of plenty. The Gothic type reads 'I am the handmaiden of the Earth', taken from Morris's poem 'Flora', later to be published in his collection *Poems by the Way*, printed by Kelmscott Press in 1891. ('Pomona' is also from a poem in this collection.)

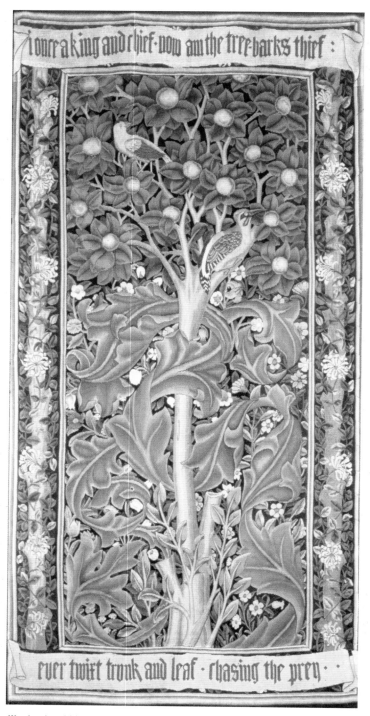

The Woodpecker, 1885
Wool on cotton lining, 307 x 156 cm (120⅞ x 61⅜ in)
• William Morris Gallery, London

· Designed by Morris, but worked by his daughter May and others at Merton Abbey. The verse at the top and bottom of this tapestry is from Morris's short poem 'The Woodpecker', from his collection *Poems by the Way*, published by Kelmscott Press in 1891.

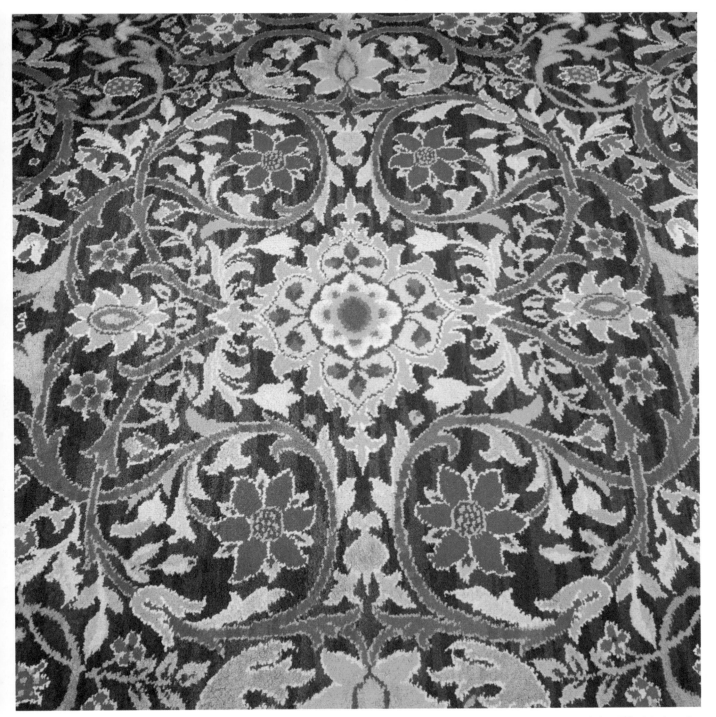

Carpet for Wightwick Manor, 1890s
Hand-knotted wool • Wightwick Manor, Wolverhampton

Wightwick Manor was built in the 1880s for a wealthy industrialist who commissioned Morris to decorate the rooms using wallpapers and fabrics. The carpet shown here was designed for one of the bedrooms, known as the Oak Room.

Foliage (detail), 1887
Woven wool on cotton, 114 x 75 cm (44⅞ x 29½ in)
• Watts Gallery, Compton, Surrey

The swirling pattern of acanthus leaves appears to dominate this tapestry (*see* page 9 to see its border trim) with the small bird and flower motifs merely punctuating the design. A contemporary piece, 'The Forest', also used the large acanthus, but was more elaborately decorated with a variety of animals.

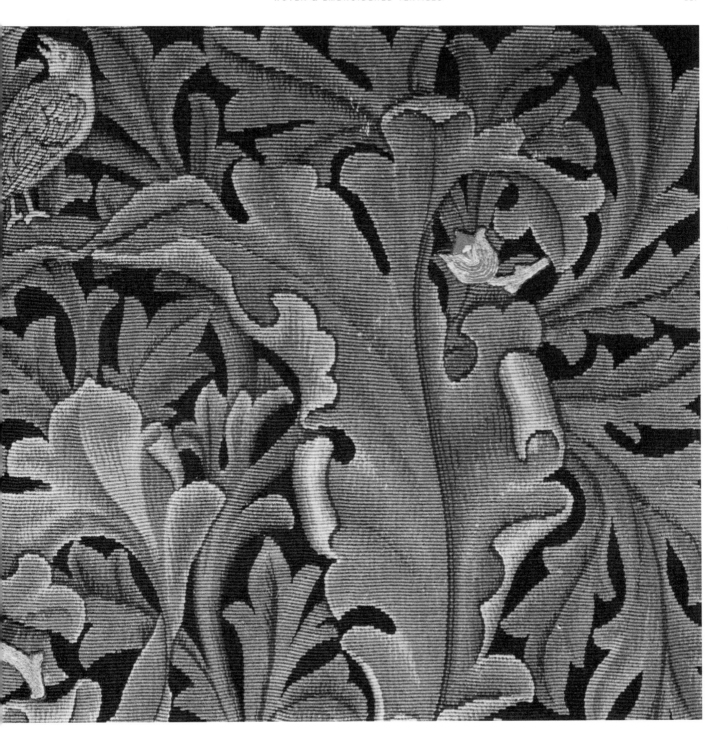

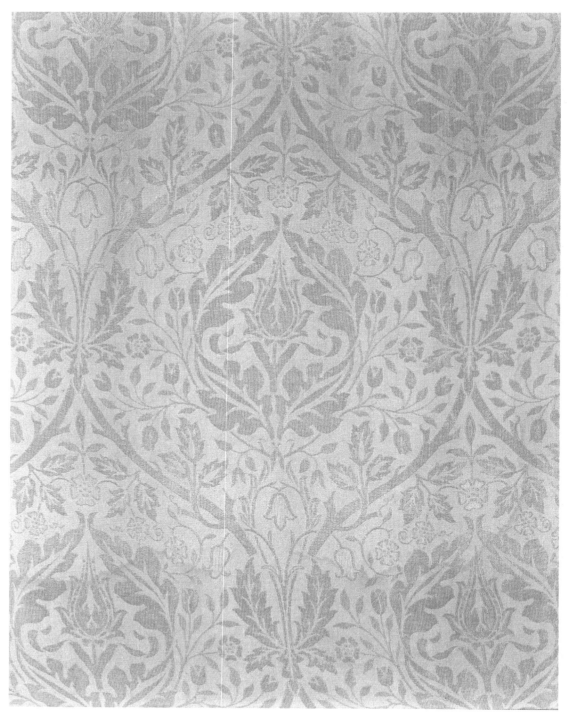

Golden Bough, 1888, by John Henry Dearle
Woven silk and linen • Private Collection/The Stapleton Collection

Another design demonstrating the move towards more formal patterning by the Firm under Dearle's direction. This one shows the influence of Owen Jones and other pattern makers rather than Morris.

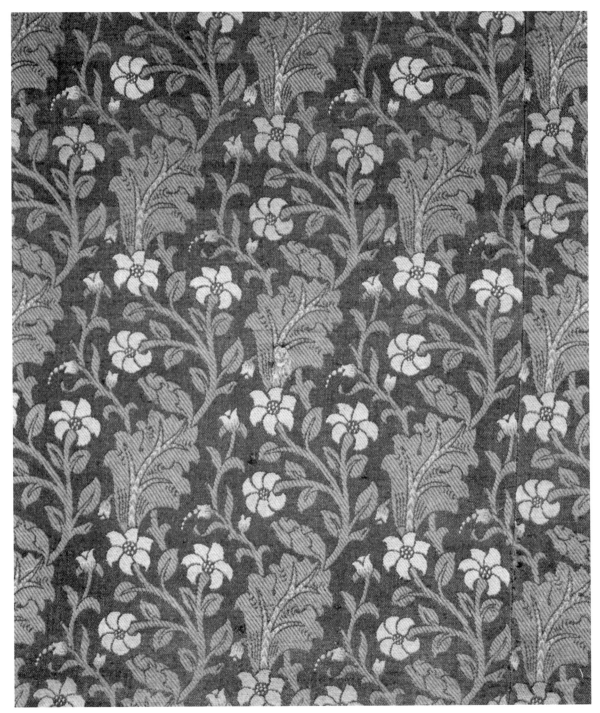

Diagonal Trail, *c.* 1893, by John Henry Dearle
Woven wool • The National Trust

A design typical of late Morris & Co., when Dearle was the chief designer, this one features a very stylized motif of acanthus leaves that marks a trend away from brightly coloured fabrics to more sombre designs.

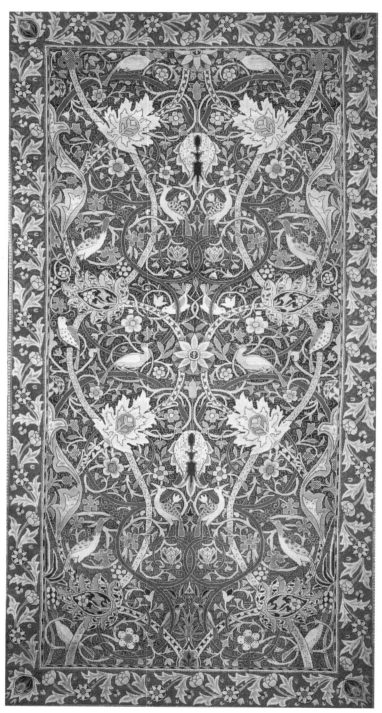

Bullerswood, 1889, by William Morris and John Henry Dearle
Hand-knotted wool on a cotton warp, 764.8 x 398.8 cm (301 x 157 in)
• Victoria & Albert Museum, London

Commissioned by the wool trader Sir John Sanderson (1868–1945) for his home 'Bullerswood', this carpet was in addition to two 'Hammersmith' carpets ordered for the house. Morris personally supervised the weaving process.

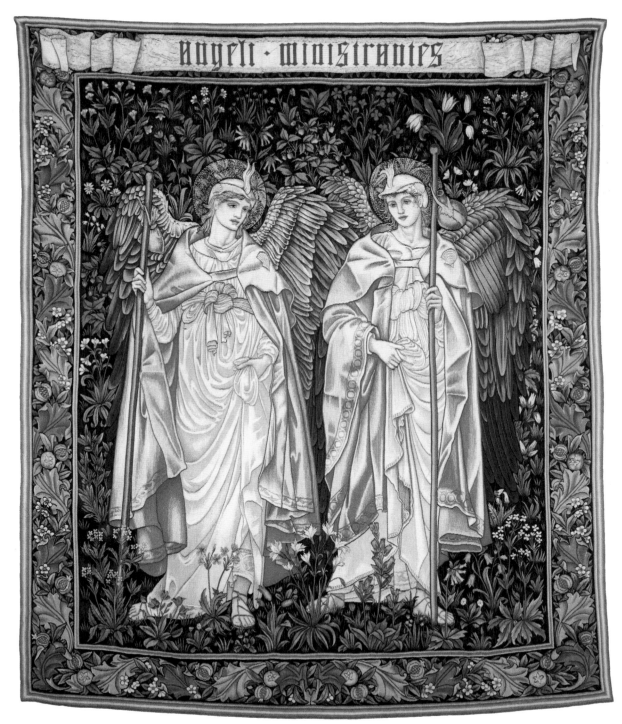

ANGELI · MINISTRANTES

**The Angeli Ministrantes, *c.* 1894, by Edward Burne-Jones
and John Henry Dearle** • Wool, silk and mohair on a cotton warp,
241.5 x 200 cm (95 x 78¾ in) • Victoria & Albert Museum, London

One of a pair of tapestries based on an original stained-glass design for Salisbury Cathedral in 1877 by Burne-Jones. It was adapted by Dearle, who applied the decorative border.

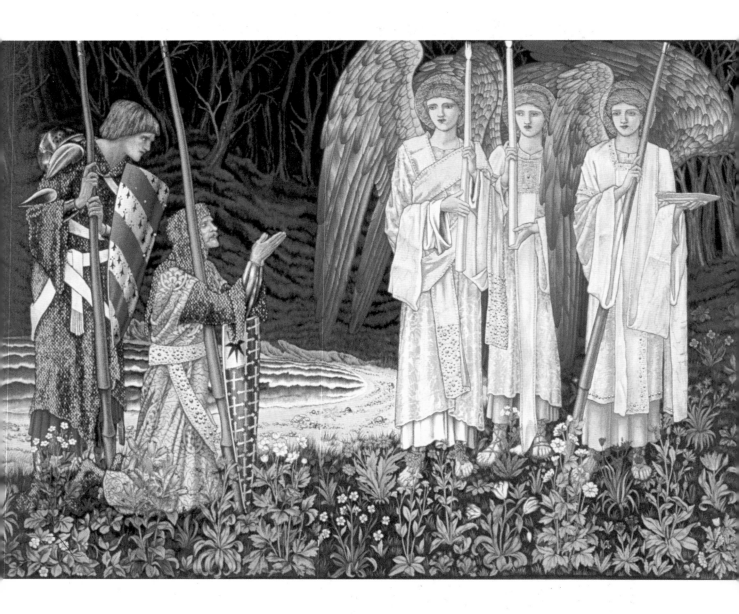

**The Attainment: The Vision of the Holy Grail to Sir Galahad, Sir Bors and Sir Perceval,
1890–94, by Edward Burne-Jones and John Henry Dearle** • Wool, silk, mohair and
camel hair weft on cotton warp, 695 x 244 cm (273⅝ x 96 in) • Birmingham Museum and Art Gallery

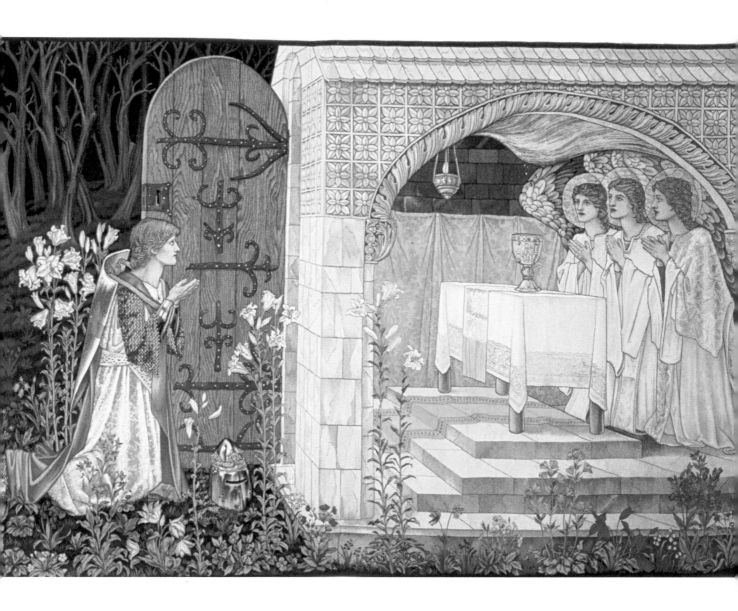

A set of six tapestries depicting scenes from the legend of King Arthur were commissioned by William Knox D'Arcy in 1890 for Stanmore Hall. This scene is the sixth, but was completed first and exhibited at the Arts and Crafts Exhibition of 1893. This particular version was made later for Lawrence Hodson of Compton Hall.

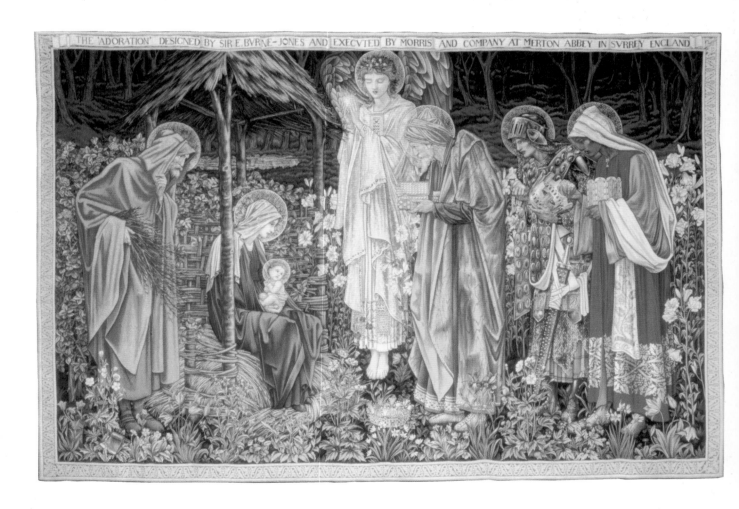

The Adoration, 1902, by Edward Burne-Jones and John Henry Dearle
Wool and silk on a cotton warp, 255 x 379 cm (100⅜ x 149¼ in)
• Hermitage Museum, St Petersburg

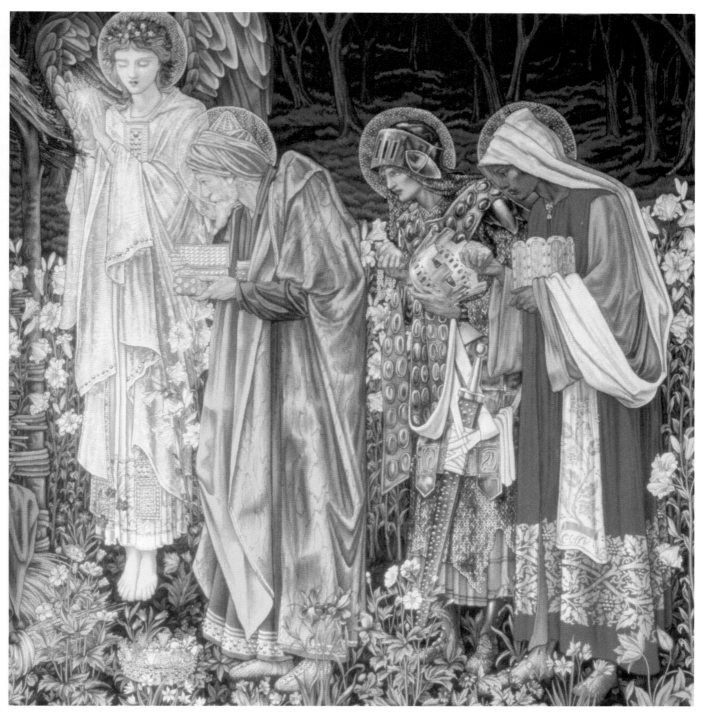

The design originated in 1888 for a decorative scheme at Exeter College, Oxford. It proved popular, with 10 versions woven for both church and secular commissions. The Russian art collector Sergei Shchukin (1854–1936) purchased this one.

Indexes

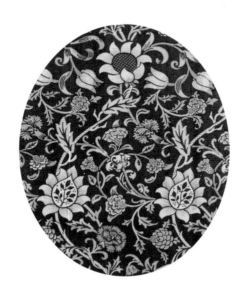

Masterpieces of Art

FLAME TREE PUBLISHING

A new series of carefully curated print and digital books covering the world's greatest art, artists and art movements.